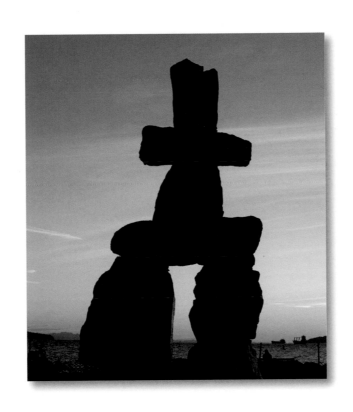

VANCOUVER

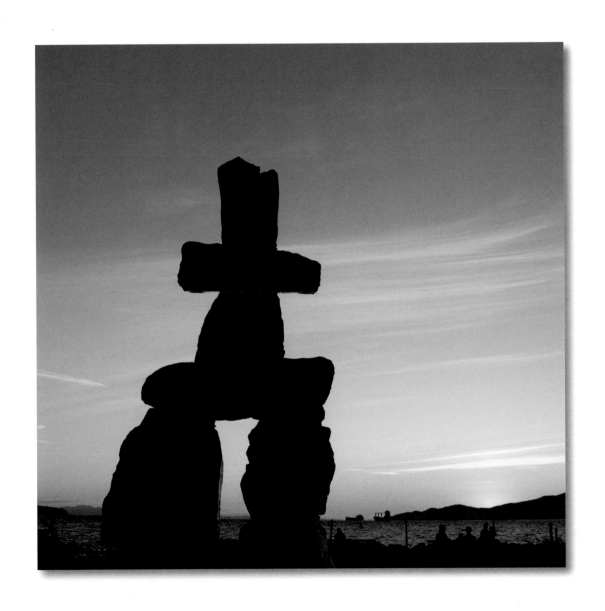

whitecap

Text by Tanya Lloyd Kyi
Edited by Elaine Jones
Photo editing by Pat Crowe
Proofread by Lisa Collins
Cover layout by Roberta Batchelor
Book layout by Steve Penner
Front cover photograph (Inukshuk at English Bay) by Jürgen Vogt
Back cover photograph (Granville Marina) by Michael E. Burch

Printed and bound in Canada by Friesens.

Library and Archives Canada Cataloguing in Publication

Lloyd, Tanya, 1973–
 Vancouver.

(Canada series)
Text by Tanya Lloyd.
ISBN-10: 1-55110-528-4 (bound).—ISBN-13: 978-1-55110-528-4 (bound).—
ISBN-10: 1-55285-592-9 (pbk.).—ISBN-13: 978-1-55285-592-8 (pbk.)

 1. Vancouver (B.C.)—Pictorial works. I. Title. II. Series.

FC3847.37.L66 1997 971.1'3304'0222 C 969-107358

The publisher acknowledges the financial support of the Government of Canada through the Canada Book Fund (CBF) and the Province of British Columbia through the Book Publishing Tax Credit.

For more information on the Canada series and other titles by Whitecap Books, please visit our website at www.whitecap.ca.

Ask visitors to describe Vancouver: they'll tell you about the strings of lights along the Lions Gate Bridge, the world-class architecture of the downtown core, or the natural haven of Stanley Park. These are the images that have made the city a destination for travellers from every continent—more than seven million each year.

But between the grandeur of the old-growth trees and the mirrored glass high-rises lie the details and diversities that continue to enthral the locals. In Vancouver, you can walk between the delicate landscapes at Nitobe Garden and the awe-inspiring First Nations artwork at the Museum of Anthropology. You can sample barbecued duck in Chinatown or Okanagan apples at Granville Island Market. You can wander past the old-town buildings of Steveston or hike the mountains that tower behind the city.

This diversity comes in part from the city's tumultuous history. For thousands of years a traditional site for First Nations peoples, the area experienced rapid change and many transformations—mill town, fishing base, gateway to the gold rush—after European settlement. It began as a small cluster of buildings along Burrard Inlet, but the first transcontinental passenger train arrived in 1887 and ships were soon docking from every corner of the globe. By the turn of the century, 10,000 called Vancouver home.

Today, Vancouver remains the hub of British Columbia's industry. Logs lie ready for export in New Westminster, coal is sent around the world from Tsawwassen, and ships dock in Burrard Inlet to be filled with grain. But the city has also achieved international importance in the arts and commerce. Downtown studios host Malaysian executives and Californian movie producers. Businesses from Korea, Japan, and India have opened offices and forged partnerships with Vancouver firms.

The images in *Vancouver* capture the sights that make the area famous, and those that endear it to business people, artists, students, and labourers. The photographers have taken their cameras into the streets to find the people and places that define the city. In their work, you can discover the roots of Vancouver, and the energy that has made it a modern focal point of Canada and the Pacific Rim.

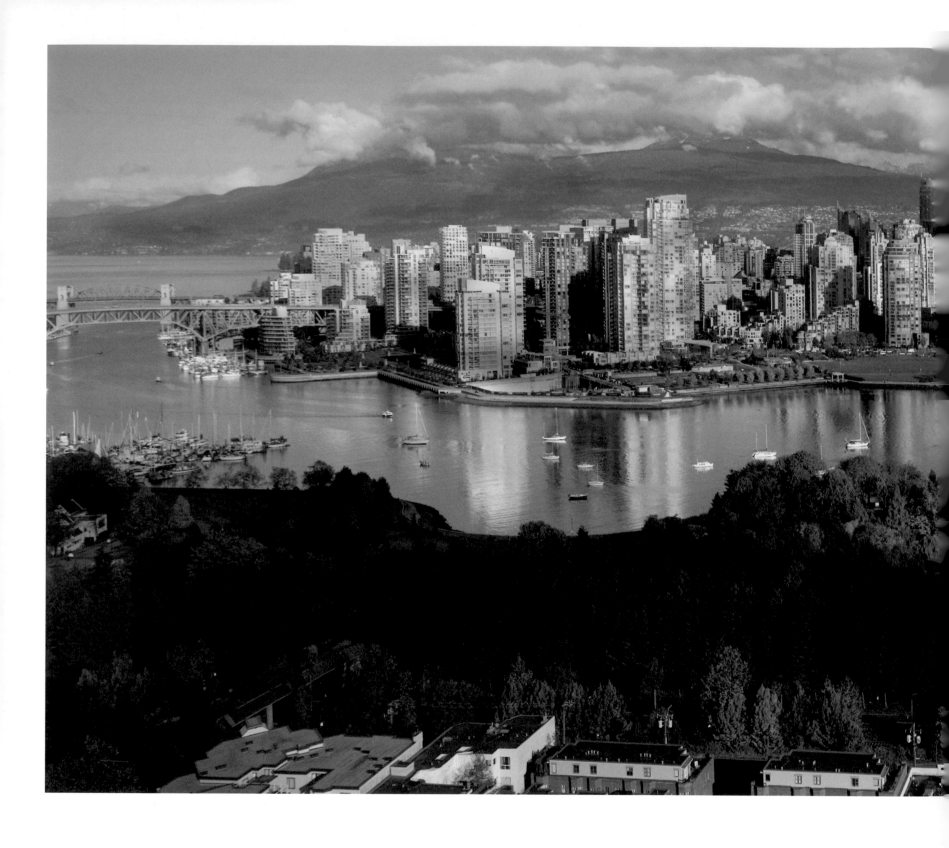

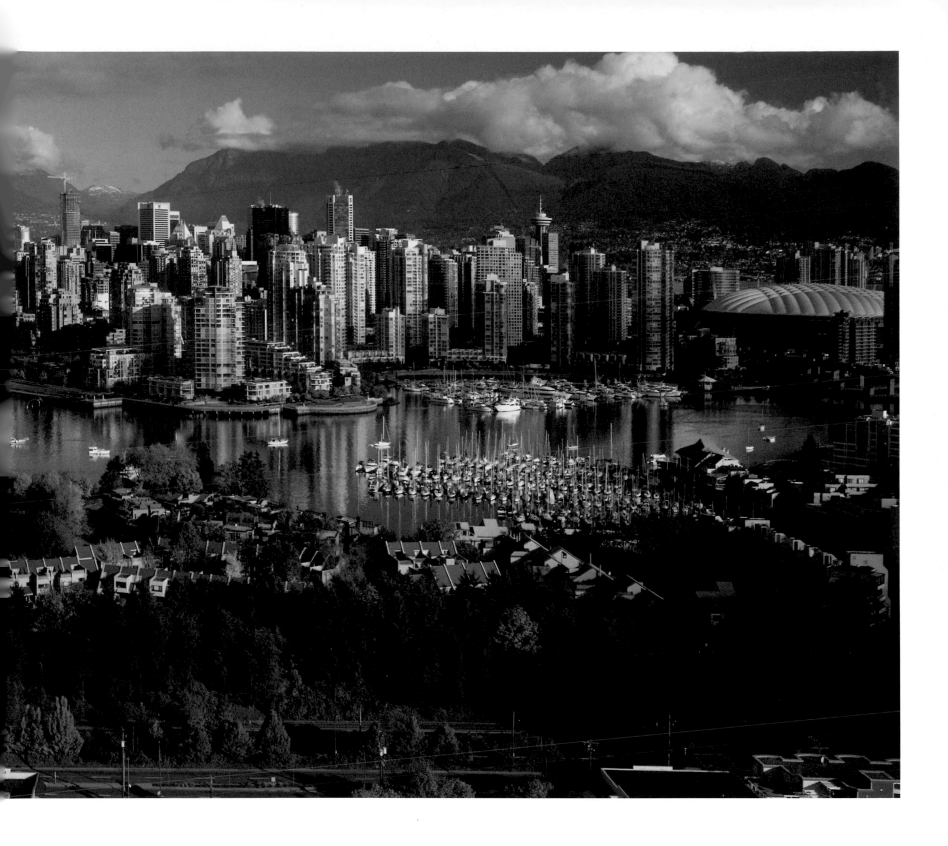

Canada's third-largest city, Vancouver is a stunning juxtaposition of modern high-rises and natural beauty. This view from Fairview Slopes showcases pleasure craft in False Creek.

Gastown's unique shops and restaurants make it a favourite with visitors. In Harbour Centre's tower, they can enjoy an eagle-eye view of both the neighbourhood and the city from the Top of Vancouver Revolving Restaurant.

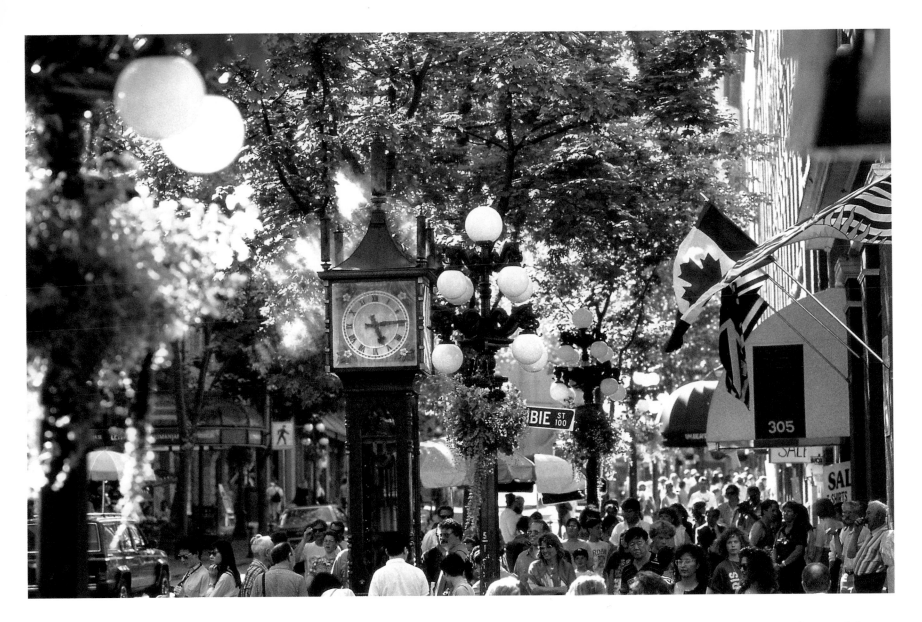

A crowd gathers on Water Street to hear the world's only steam-powered clock sound its hourly whistle. Operated by an underground system, the clock was built in 1977 by Raymond L. Sanders in celebration of historic Gastown's restoration.

John "Gassy Jack" Deighton is one of historical Vancouver's most colourful characters. The talkative riverboat captain settled in Vancouver in the late 1800s to open the city's first saloon.

FACING PAGE –
On the eastern edge of downtown, Victory Square is the site of Vancouver's annual Remembrance Day ceremony. The Dominion Building in the background was the British Empire's tallest building when it was completed in 1910.

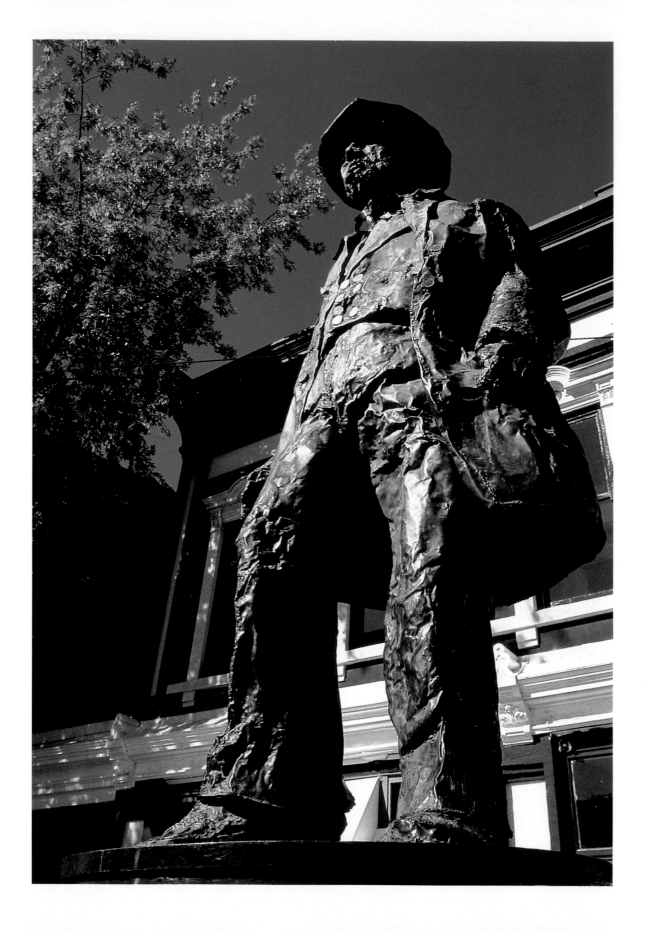

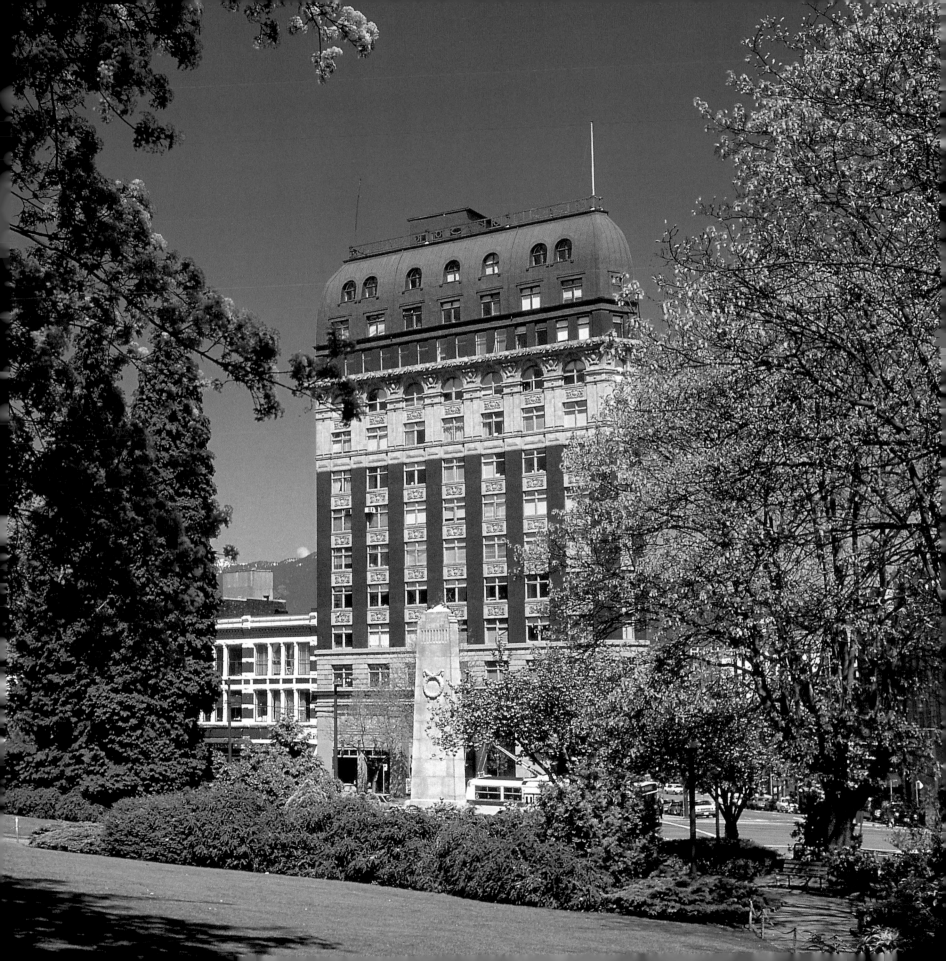

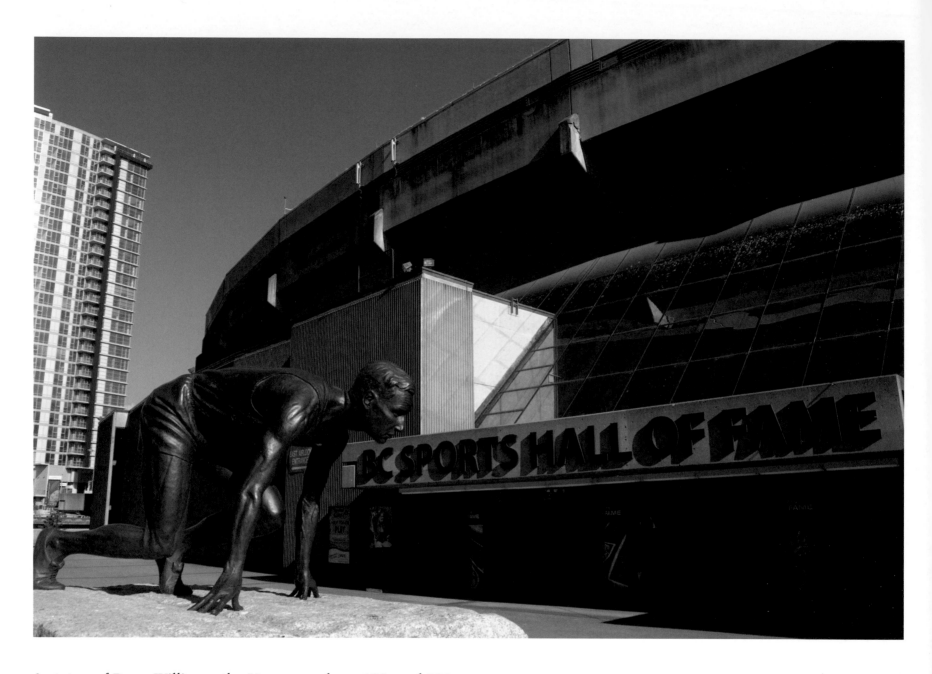

A statue of Percy Williams, the Vancouver-born 100- and 200-metre Olympic gold medalist, graces the entrance to the BC Sports Hall of Fame at BC Place Stadium, Canada's first domed stadium.

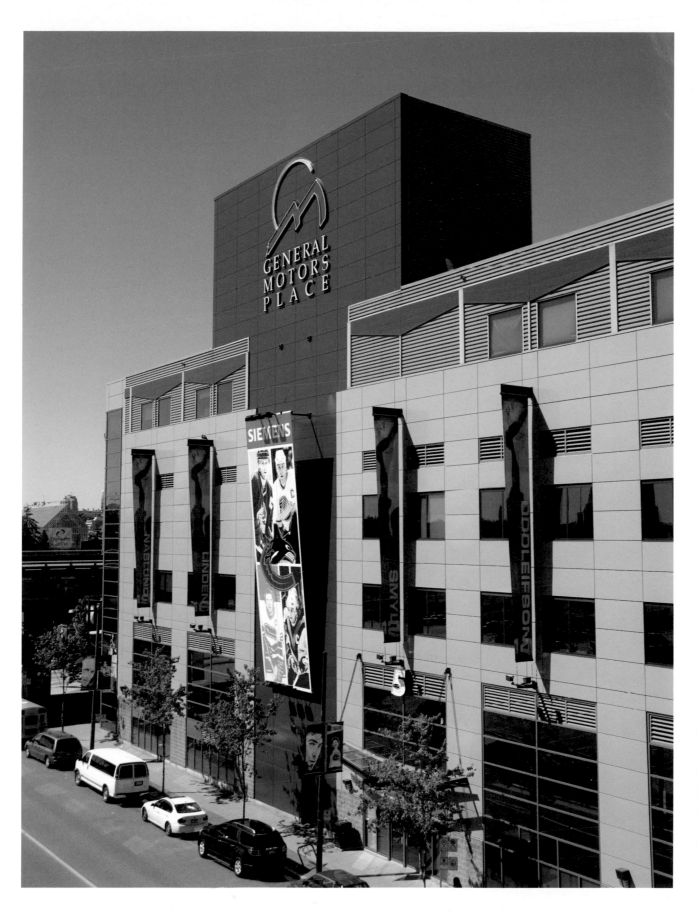

General Motors Place, the hockey arena in downtown Vancouver, seats 18,630, and is home to the National Hockey League's Vancouver Canucks.

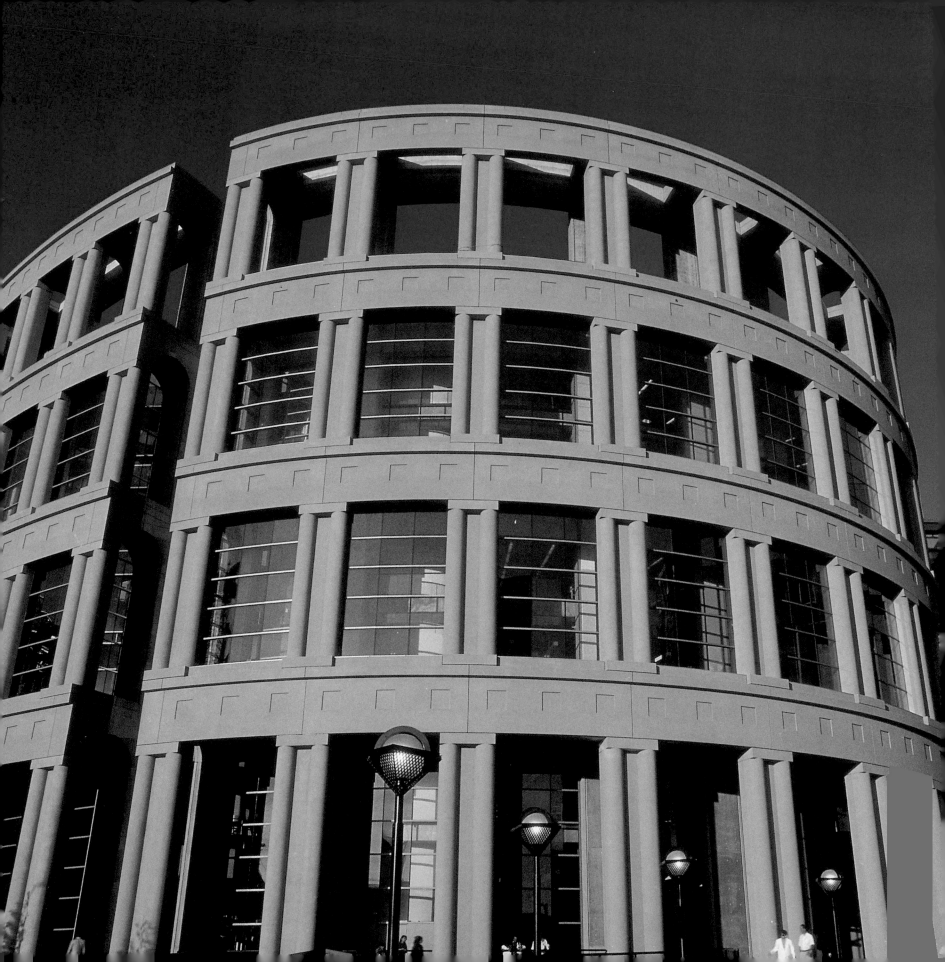

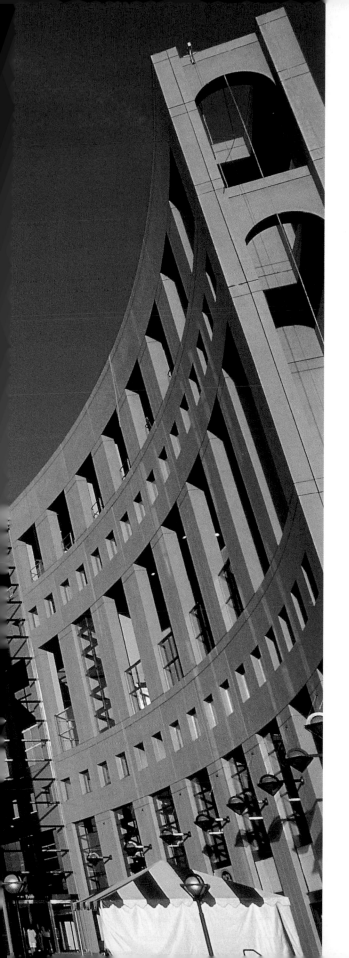

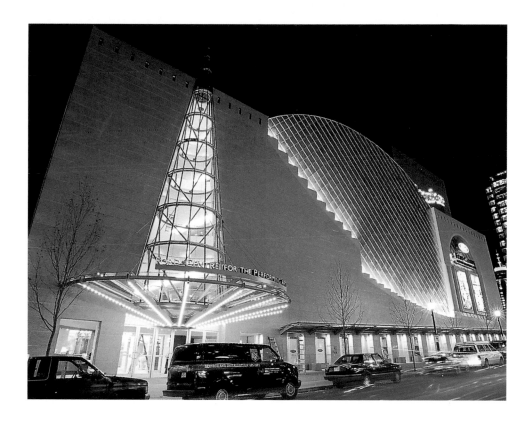

Vancouver is a western Canadian centre for the arts. It boasts the Vancouver Symphony Orchestra, the Vancouver Opera, Ballet British Columbia, and countless theatre groups. One of the city's venues is the Centre in Vancouver for Performing Arts, where actors and singers stage acclaimed mega-musicals.

The sweeping curves of the Vancouver Public Library, designed by architect Moshe Safdie, draw visitors into a state-of-the-art facility. The building boasts extensive research tools, reading areas with natural light, and fibre optic technology that can accommodate up to 800 computer terminals.

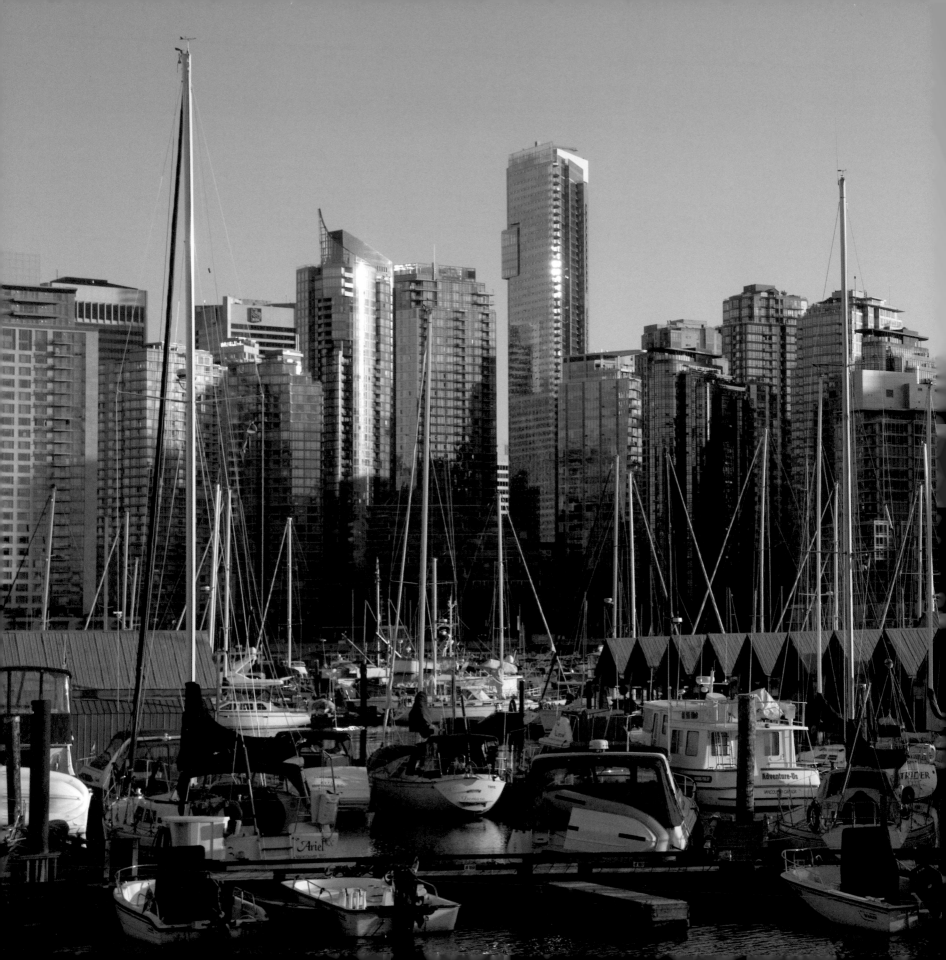

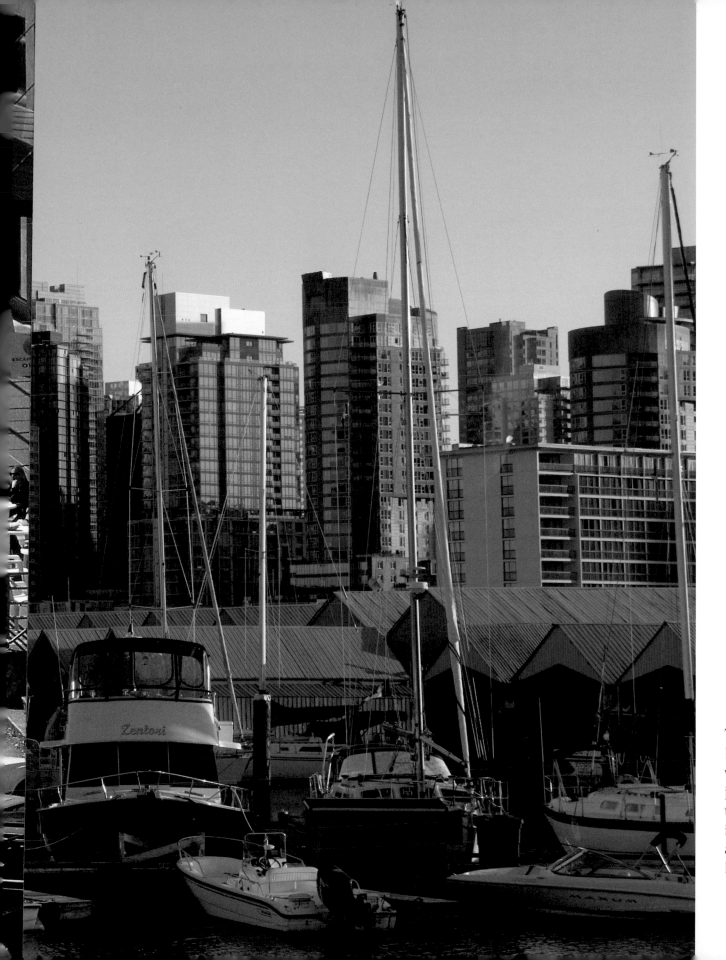

The picturesque Coal Harbour marina contrasts with downtown high-rises just to the south. The tallest tower visible, at 61 storeys, is the highest in the city, and houses the Shangri-La Hotel on its first 15 floors.

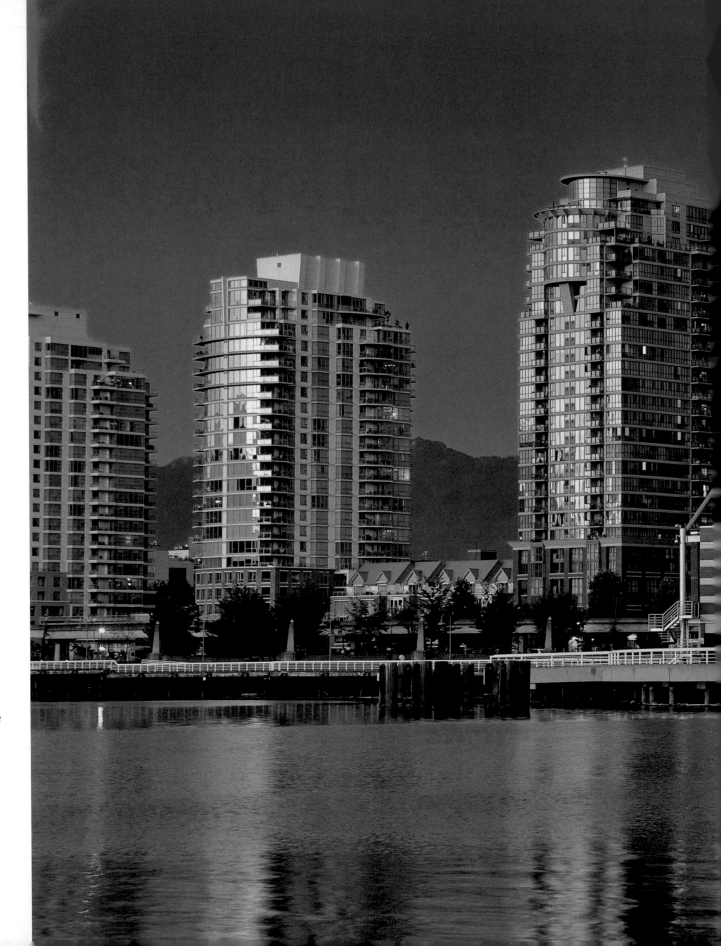

Built for the 1986 World Exposition, the TELUS World of Science, also known as Science World, is a landmark of the Vancouver skyline. Inside the space-age dome are hundreds of exhibits and hands-on displays. Its popular OMNIMAX Theatre is the second-largest domed theatre in the world.

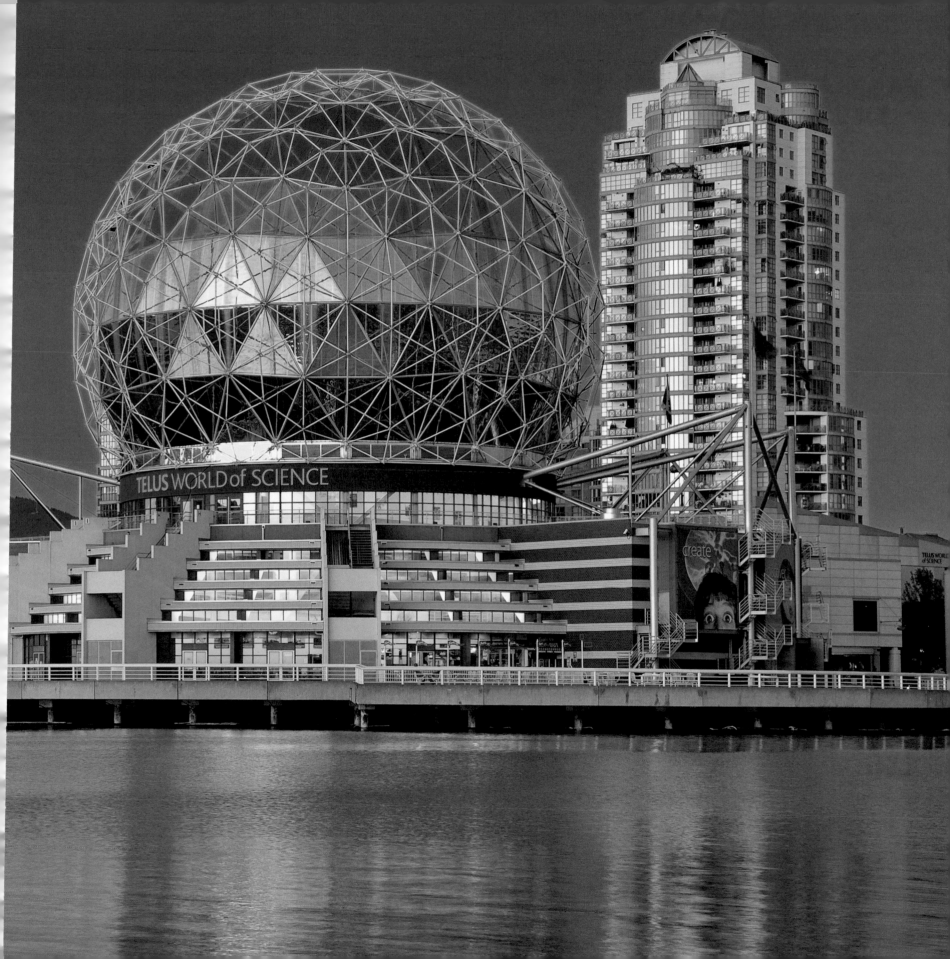

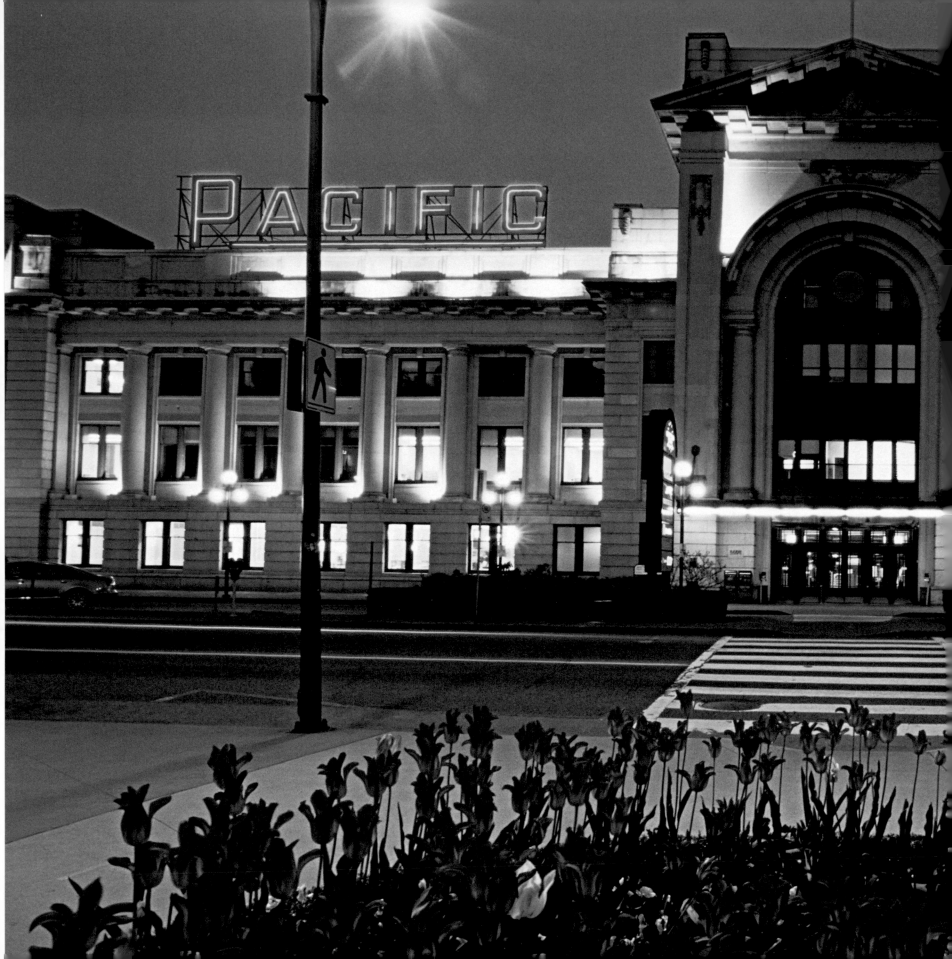

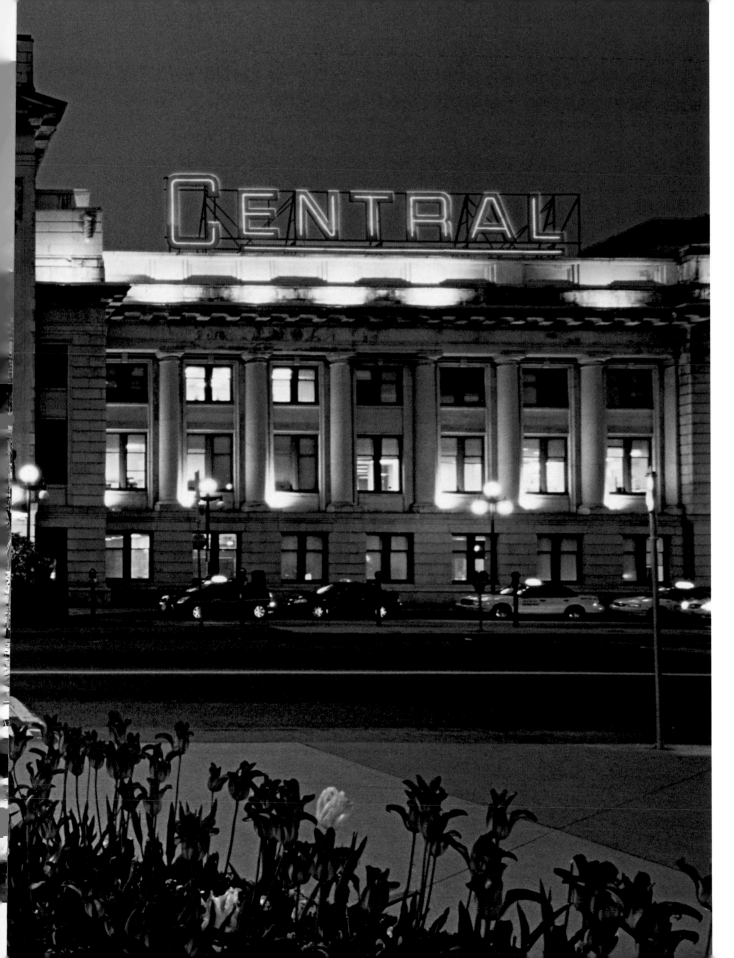

Originally built in 1919 as the terminal for Canadian Northern Railways, the restored Pacific Central station now serves passengers of several bus and rail lines, including VIA Rail and Amtrak.

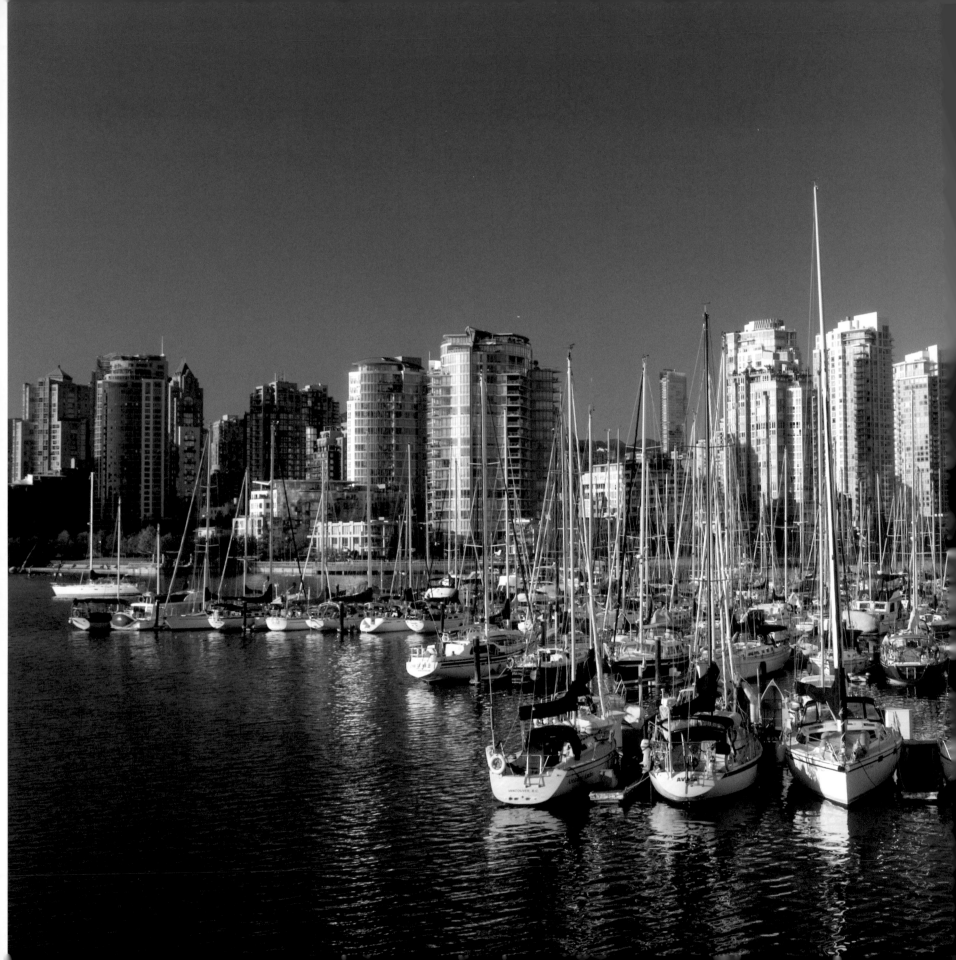

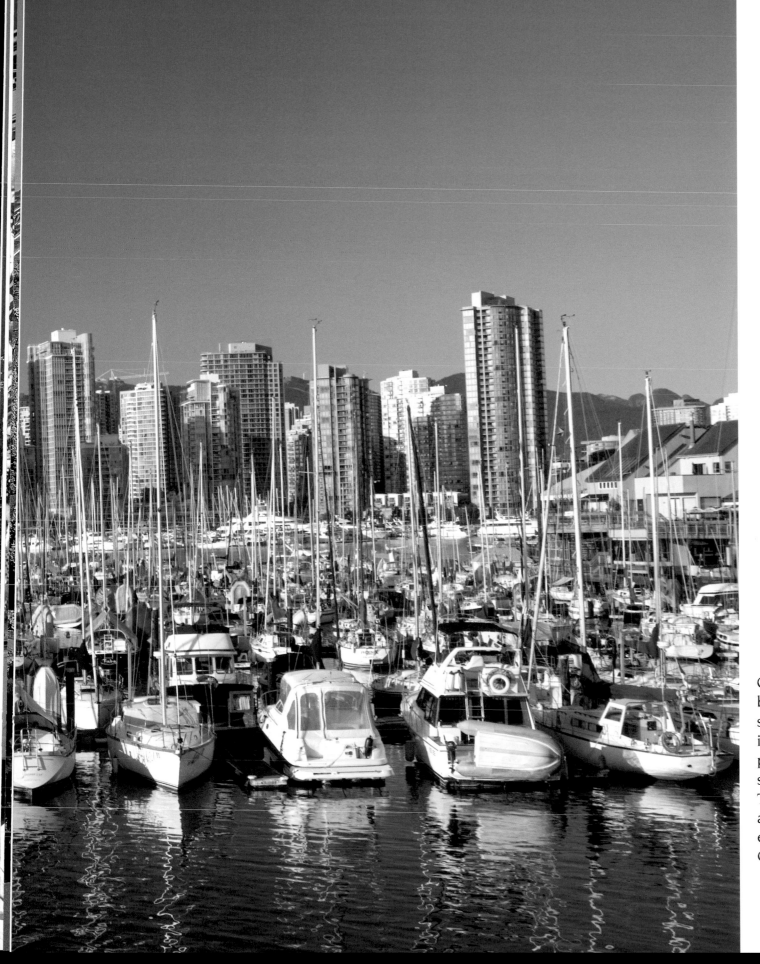

Once an industrial basin, False Creek now shelters upscale housing developments, parks, a picturesque seawall, and a marina. This "creek" is actually an inlet, mistakenly named by Captain George Richards in 1859.

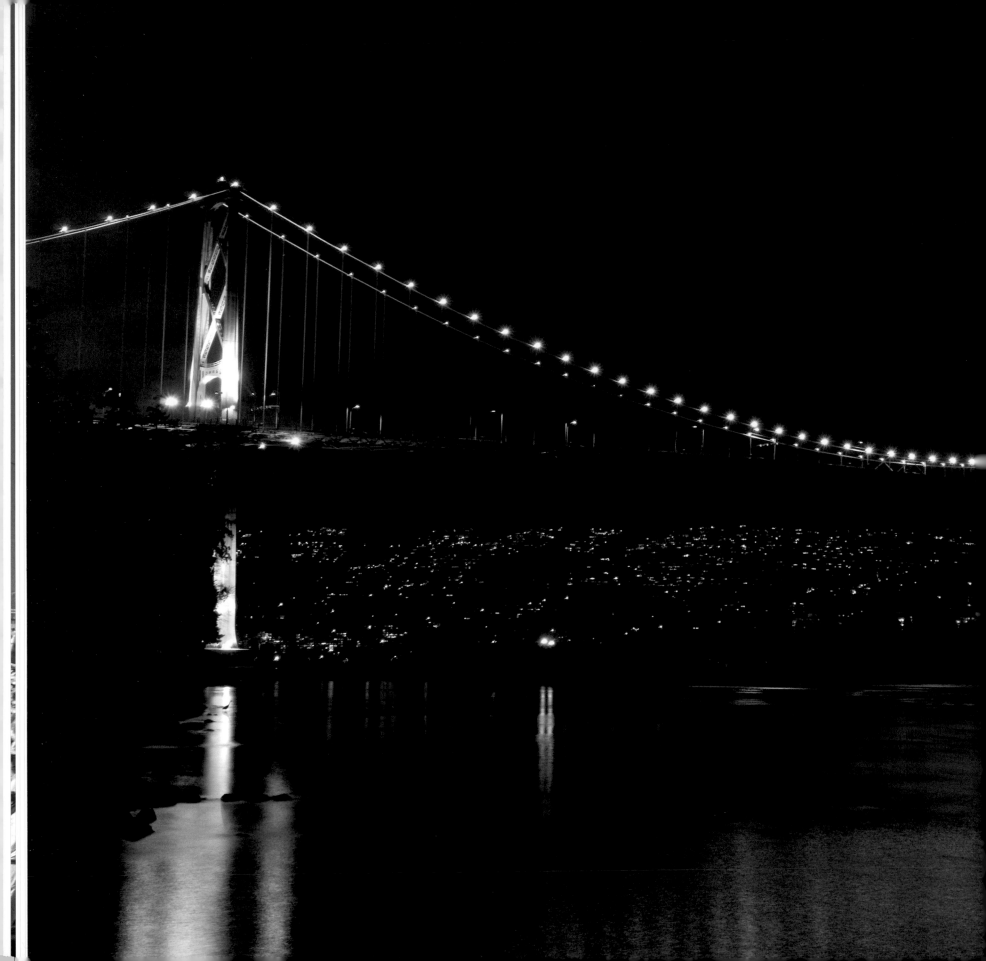

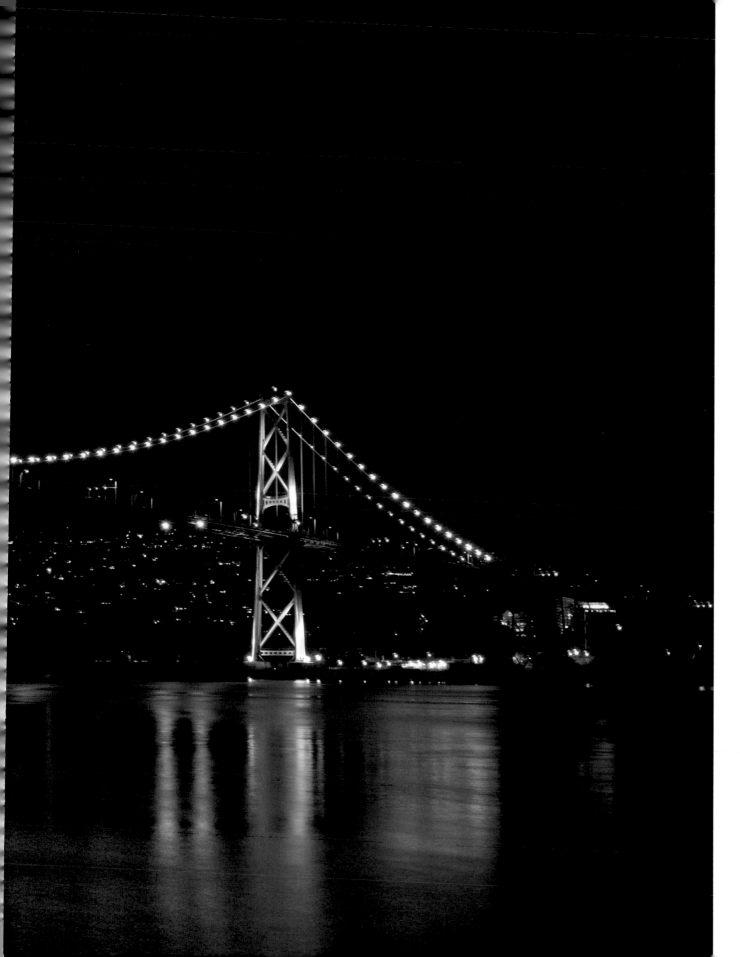

Hundreds of lights outline the cables of Lions Gate Bridge. Officially opened in 1939, the bridge was financed by the Guinnesses (the same family known for Guinness beer), who wanted to increase access to their land in West Vancouver.

Presiding over English Bay in Vancouver's West End, this inukshuk was originally part of the Northwest Territories pavilion at Expo 86. Used as milestones or landmarks in the Arctic, inukshuks have come to symbolize friendship and hope. The inukshuk is the official emblem for the 2010 Olympic and Paralympic Winter Games in Vancouver.

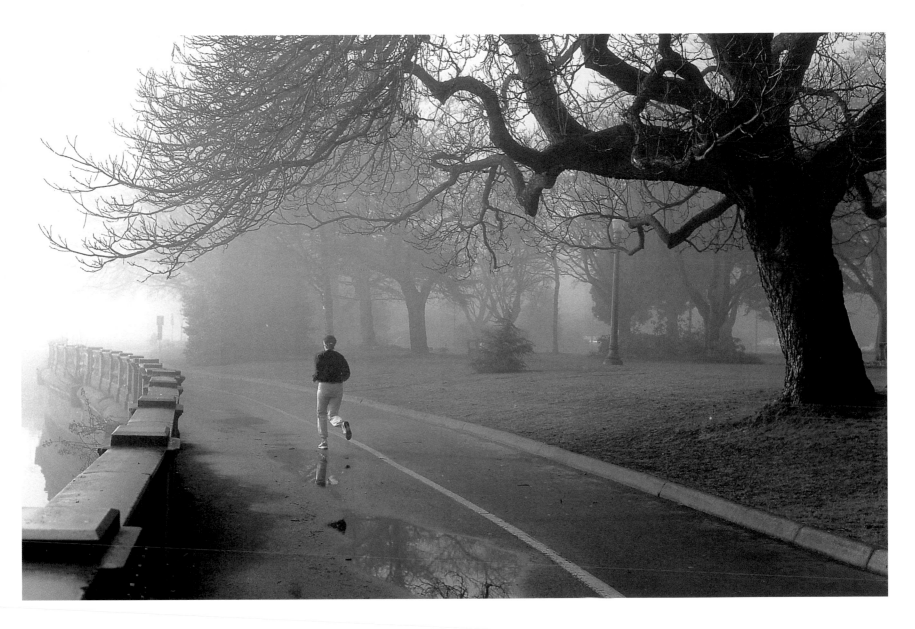

The seawall, which encircles much of the park, stretches for ten kilometres along the shore.

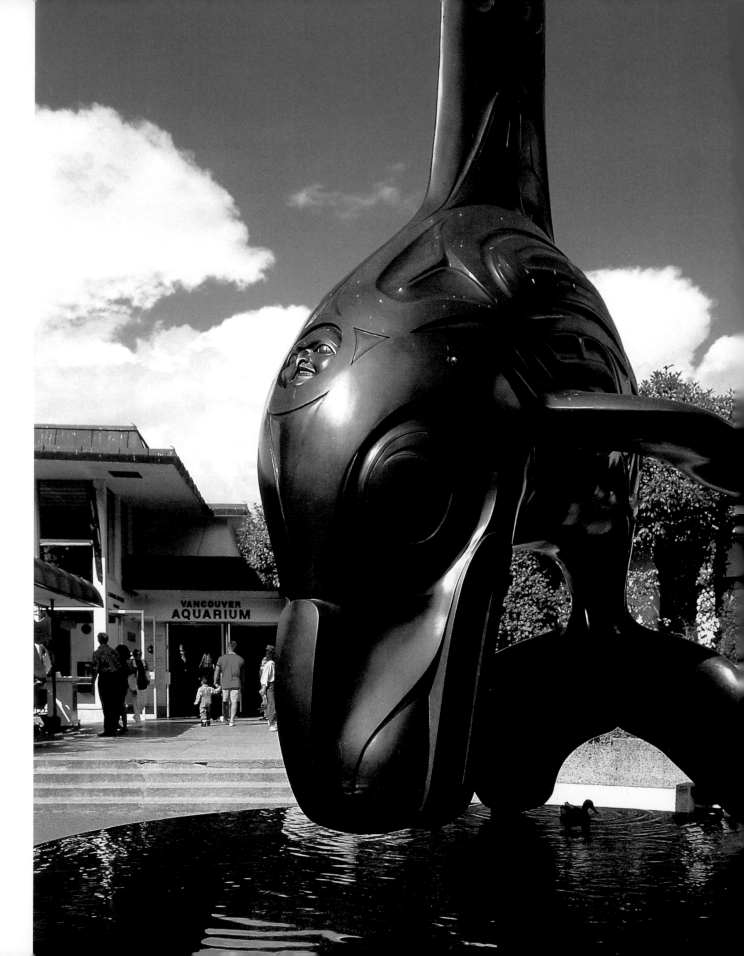

This bronze orca greets visitors to the Vancouver Aquarium. The 5.5-metre sculpture is the work of British Columbia artist Bill Reid.

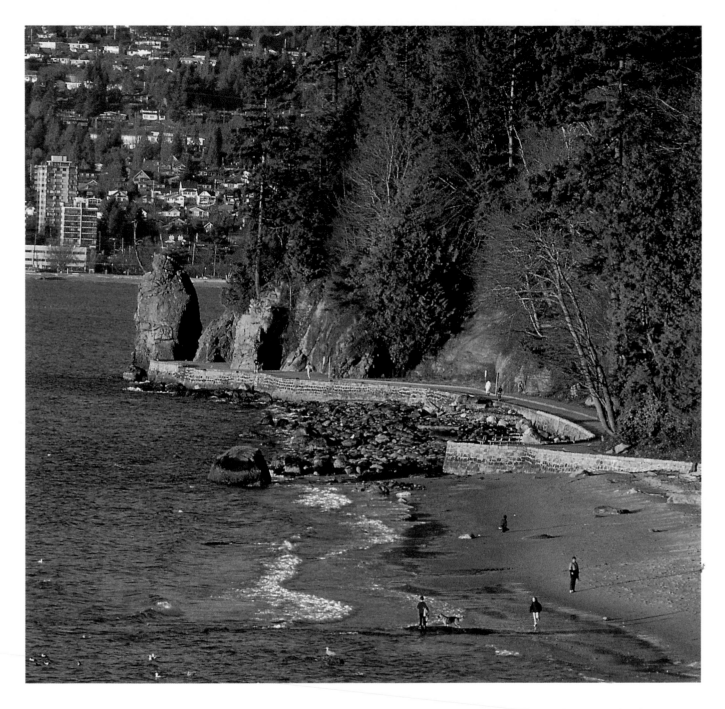

The Stanley Park seawall winds from Siwash Rock towards the beach, where a few brave walkers test the waves. According to First Nations' legends, the looming Siwash Rock at the tip of the point was once a young man. He was made immortal because of his devotion to the gods.

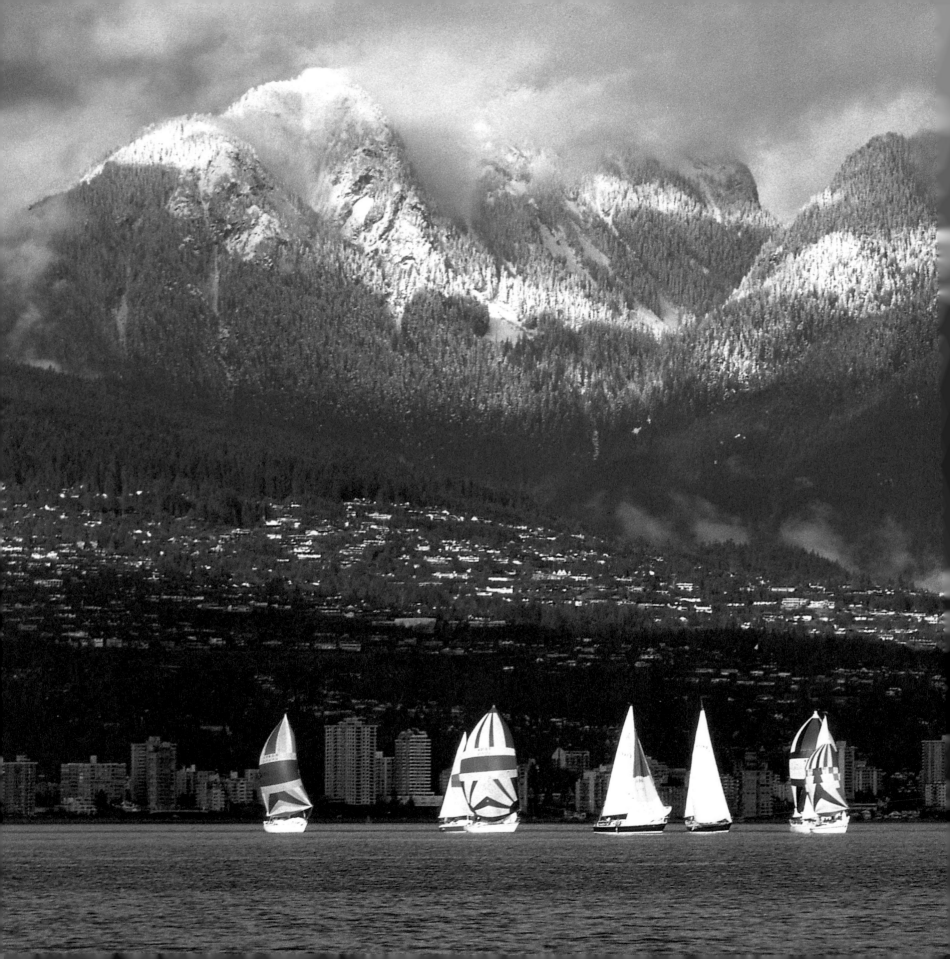

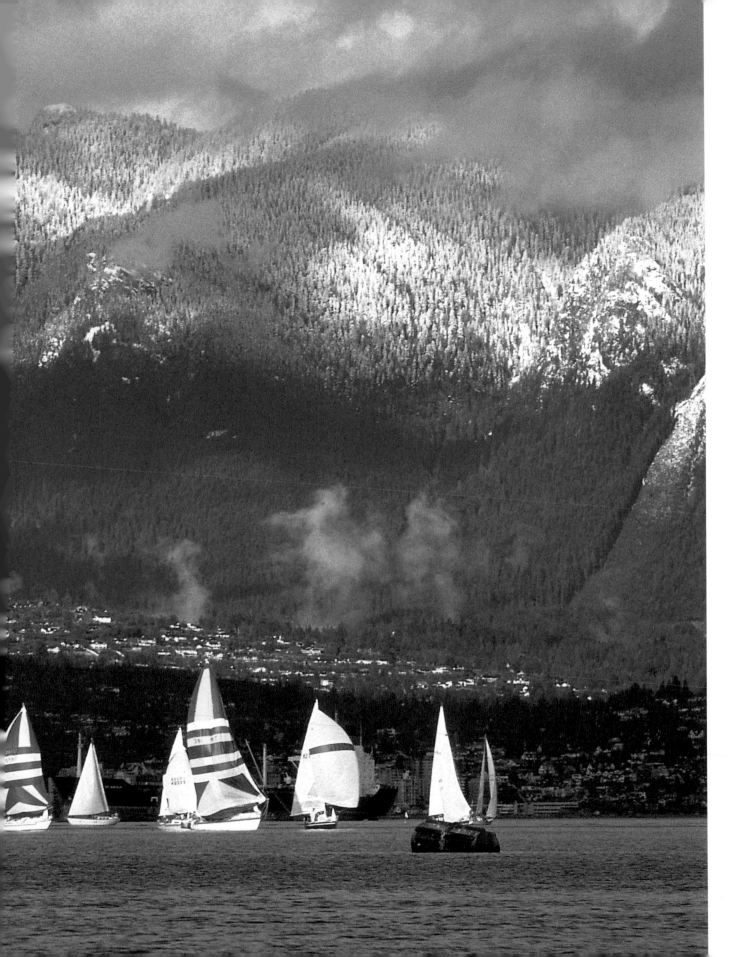

Boats spread their sails near Spanish Banks, named for the 1791 visit of Spanish explorer Jose Maria Narvaez.

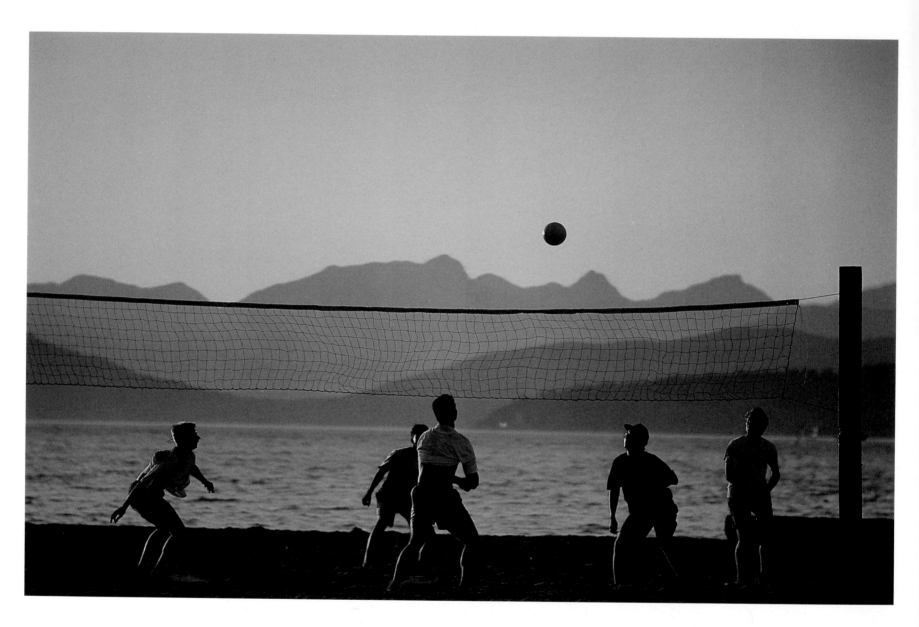

Players fight for the last few points of a beach
volleyball game as the sun sets behind them.

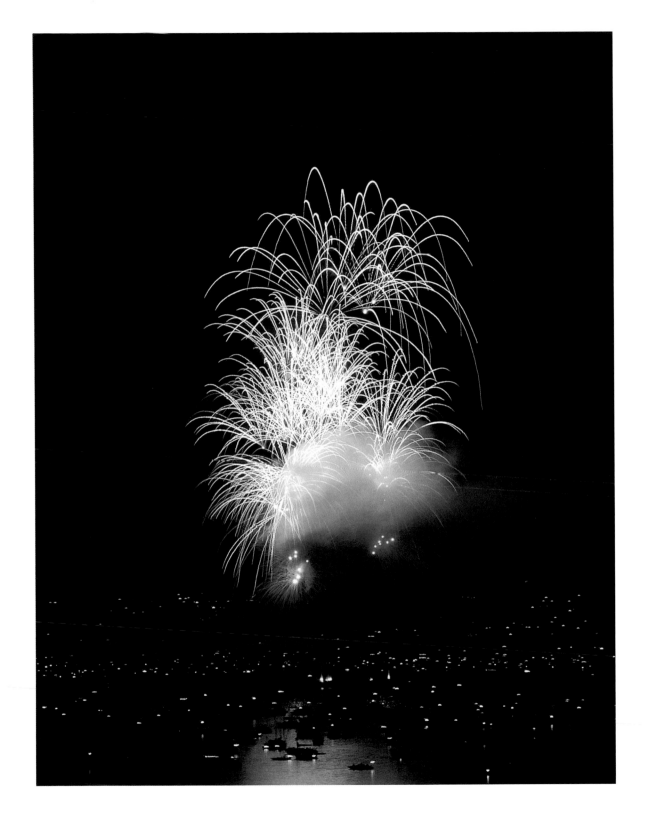

Spectators line the shore and boaters crowd the waters of English Bay to watch as a giant pyrotechnic display lights up the sky.

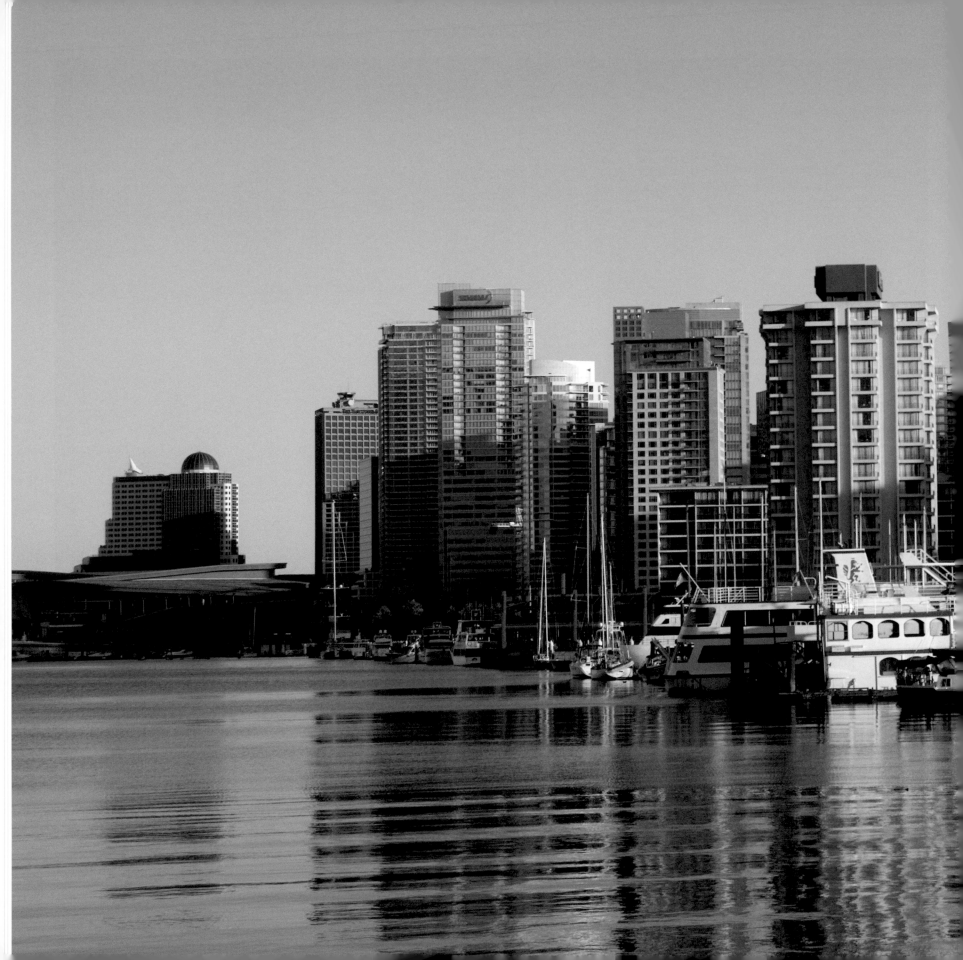

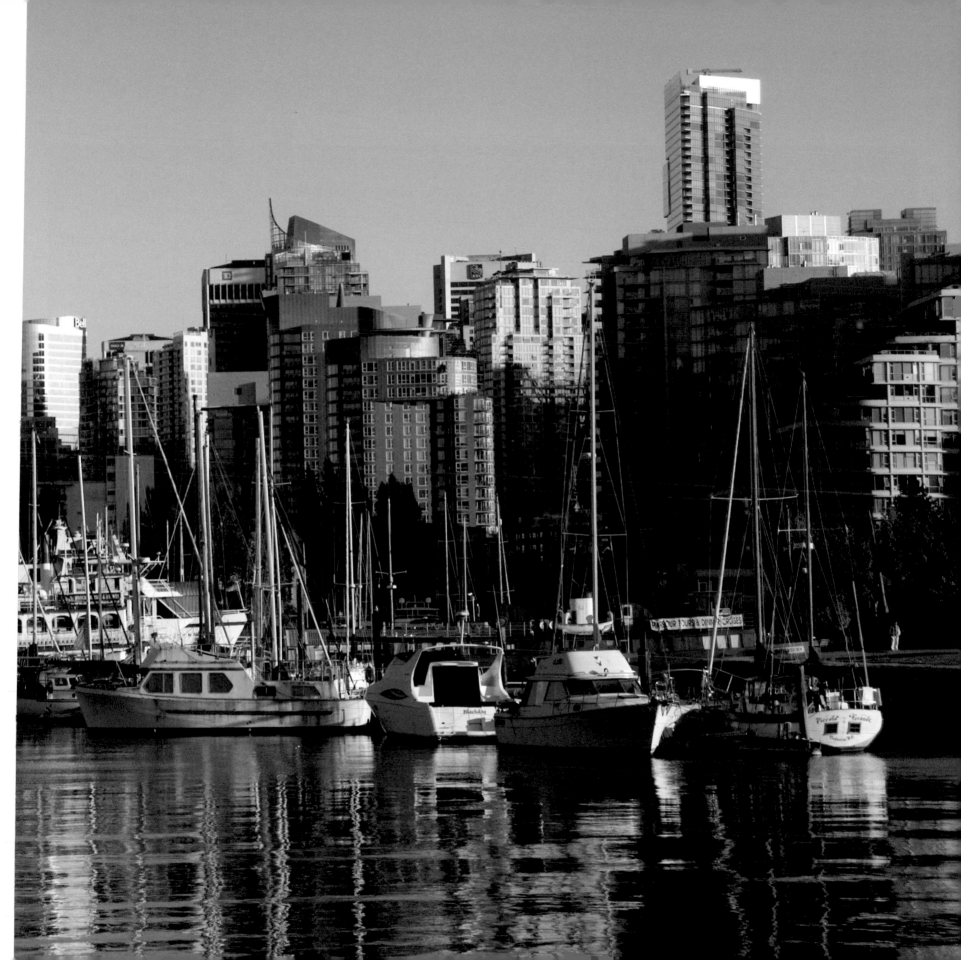

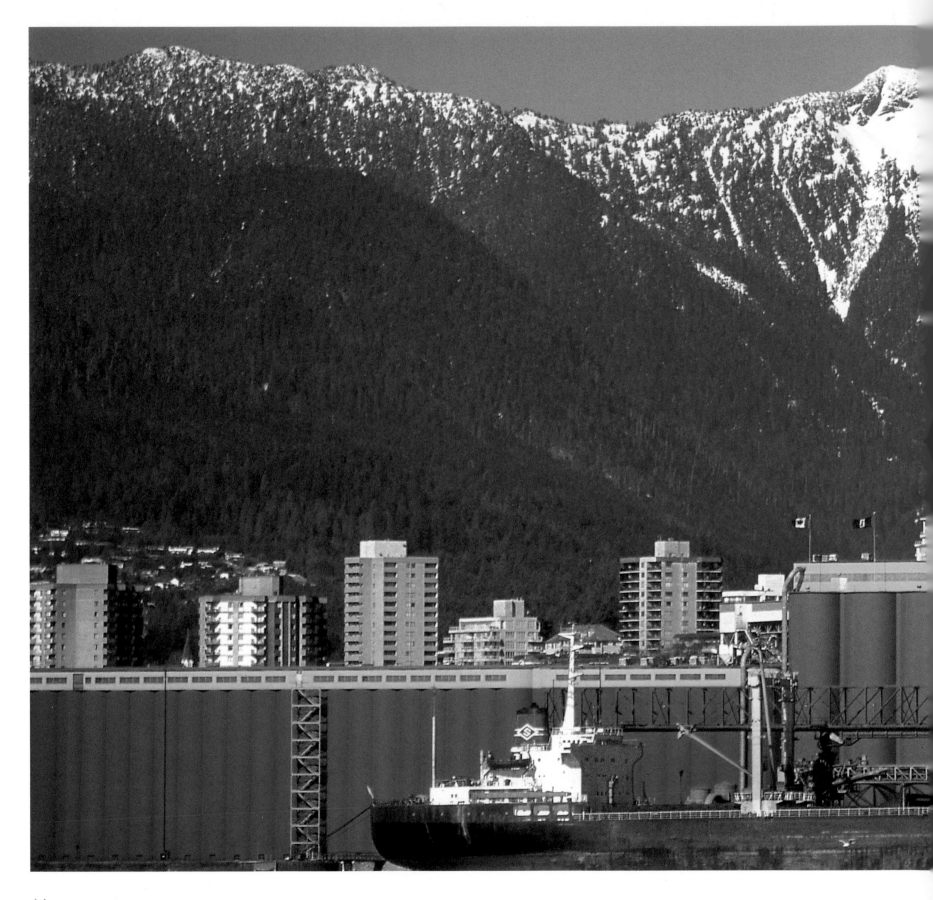

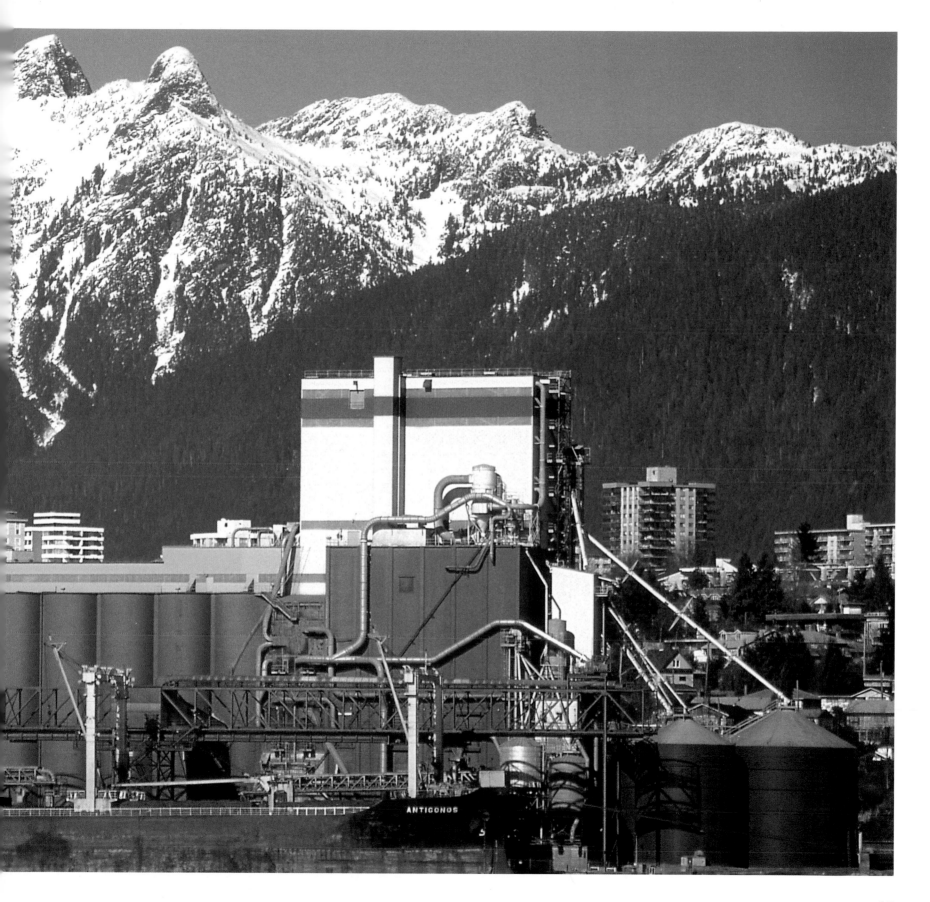

The Capilano
Suspension Bridge
sways a breathtaking
69 metres above the
Capilano Canyon. The
first bridge was built
here in 1889.

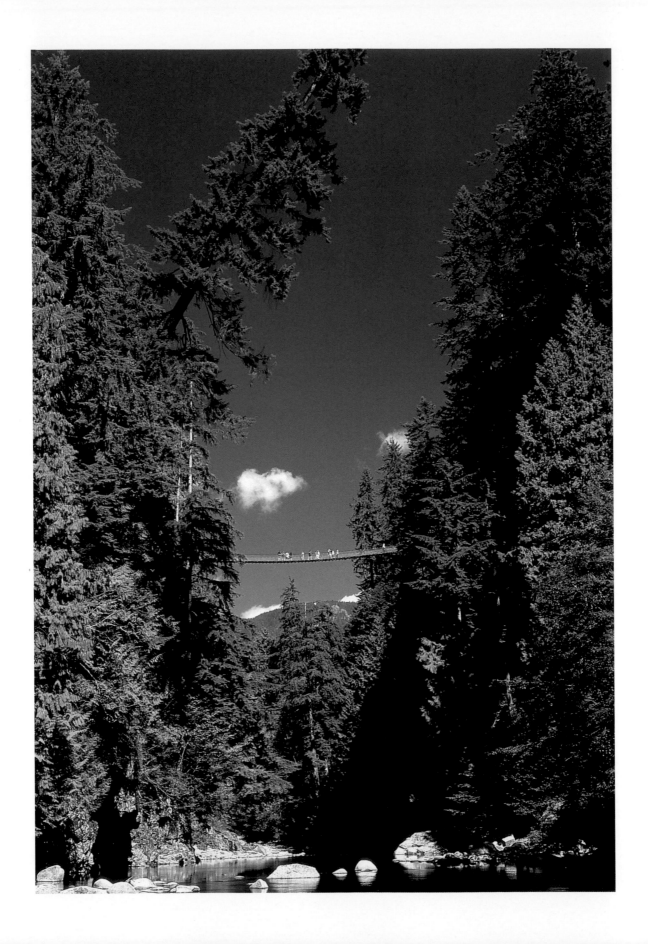

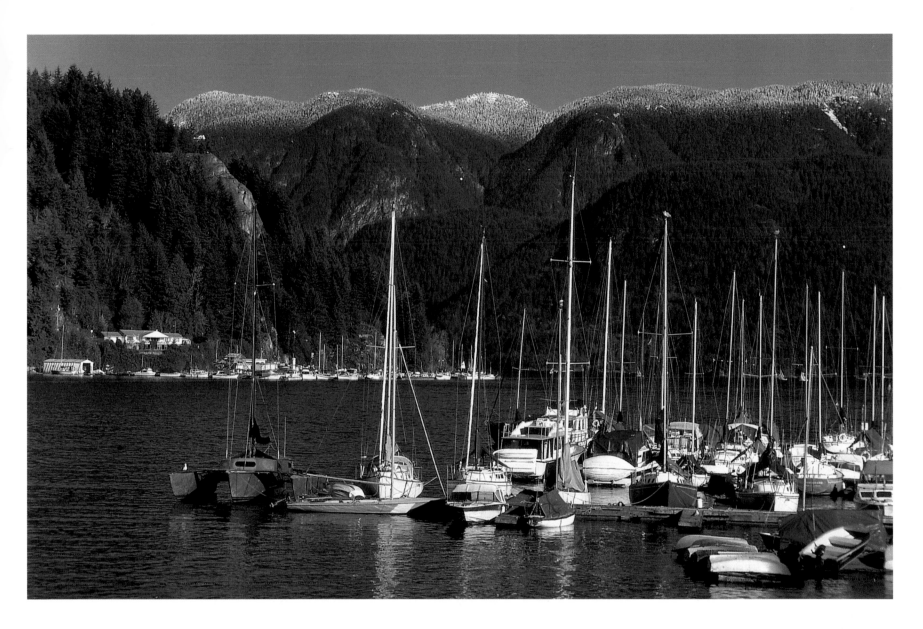

Sailboats and catamarans sway tranquilly at a Deep Cove dock in North Vancouver.

OVERLEAF –
The Point Atkinson lighthouse is part of Lighthouse Park in West Vancouver. The first lighthouse was built on Point Atkinson in 1874. This one is 18 metres and was built in 1914.

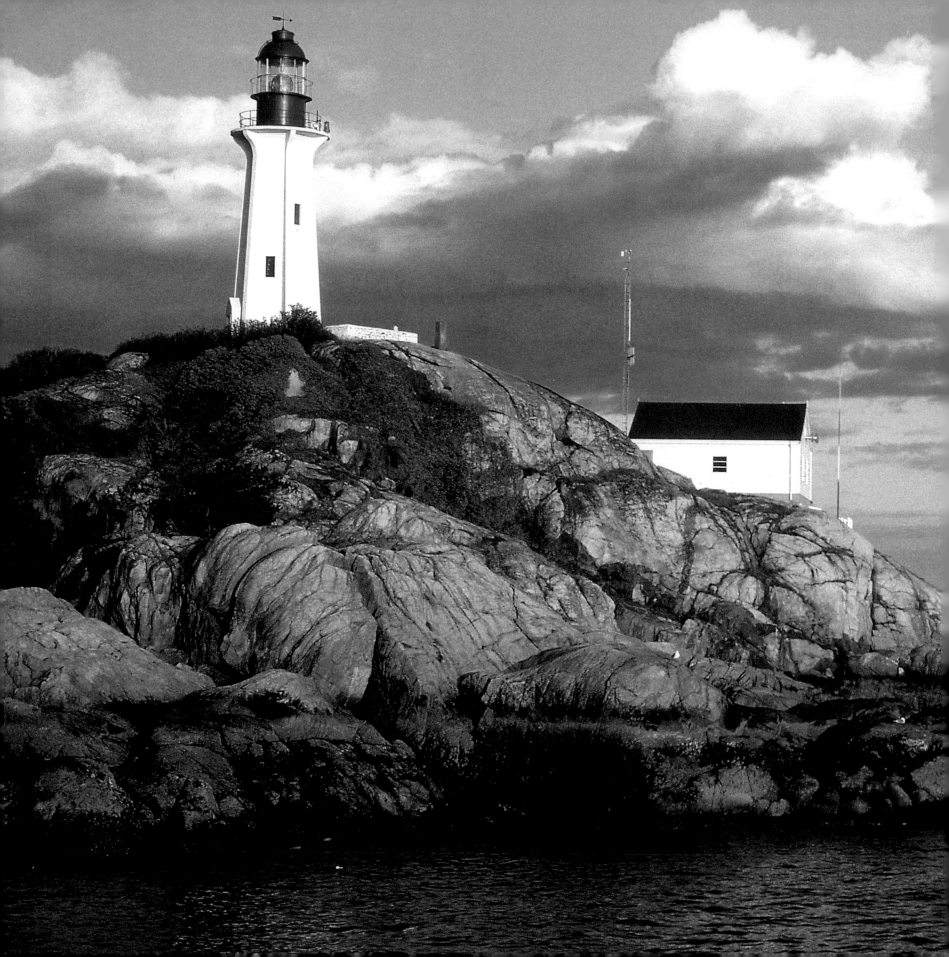

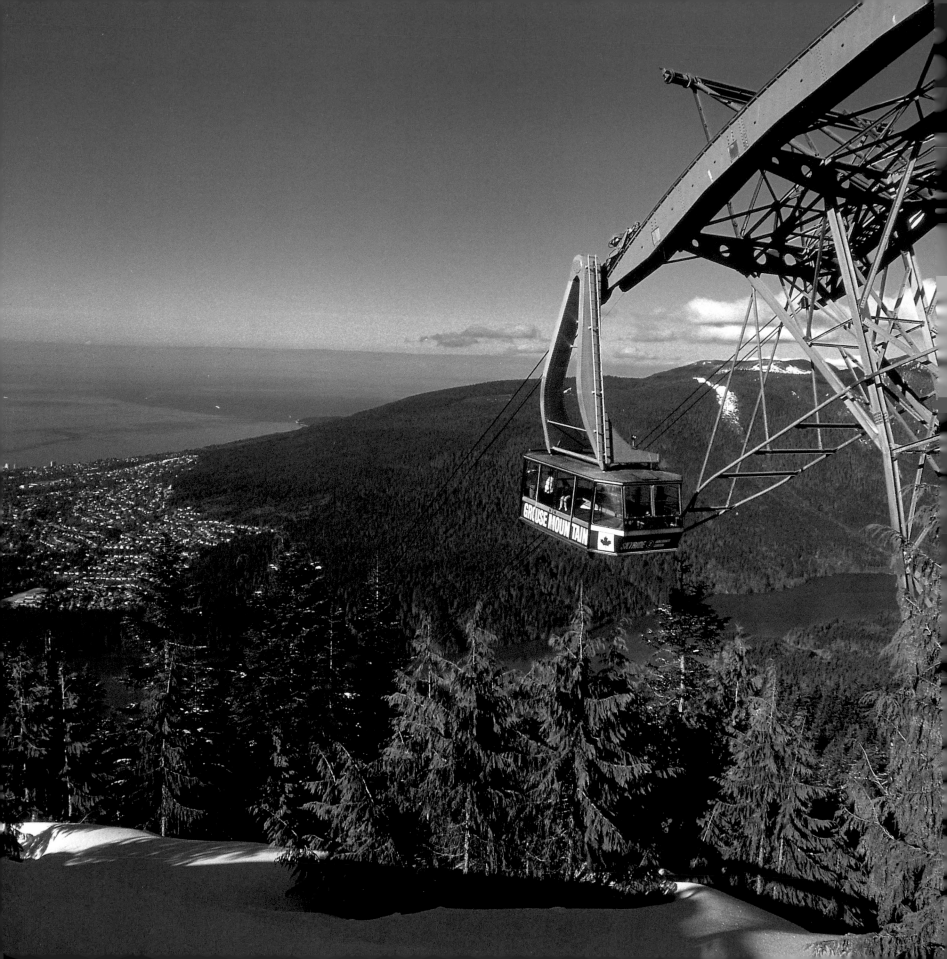

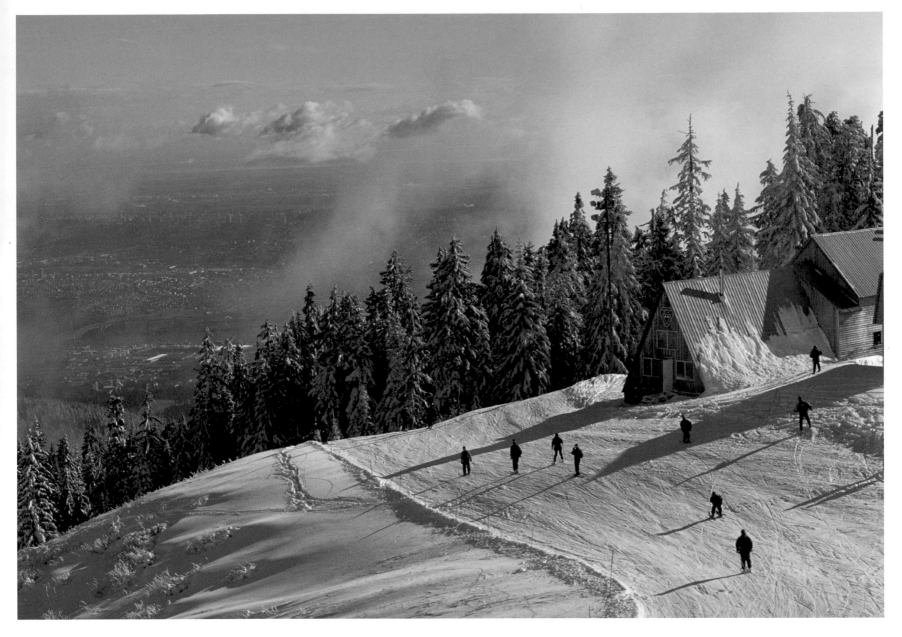

Cross-country skiing is just one of the winter activities offered on Grouse Mountain, on Vancouver's North Shore. Visitors can also enjoy snowshoeing and ice-skating or go on a sleigh ride.

The Grouse Mountain Skyride lifts skiers to 1,128 meters above the city. In the summer, hikers use the Skyride as a quick way down after climbing the strenuous "Grouse Grind" trail.

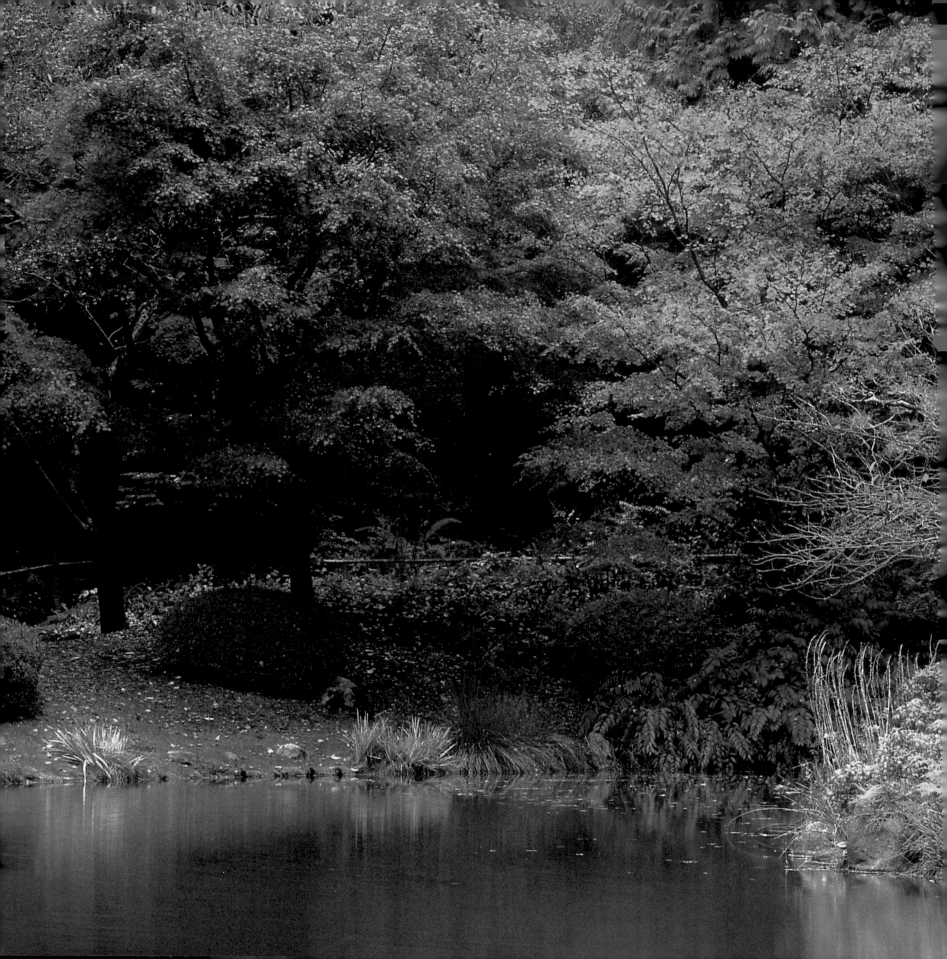

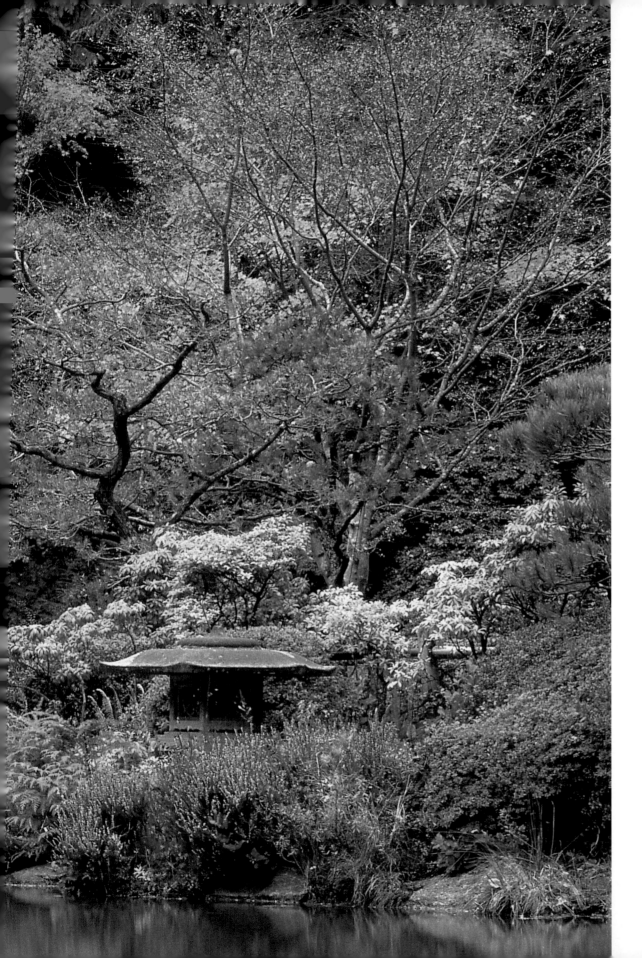

Authentically designed and carefully landscaped, Nitobe Garden was opened at the University of British Columbia in 1960. Its one-hectare expanse features indigenous plants of B.C. as well as those imported from Japan.

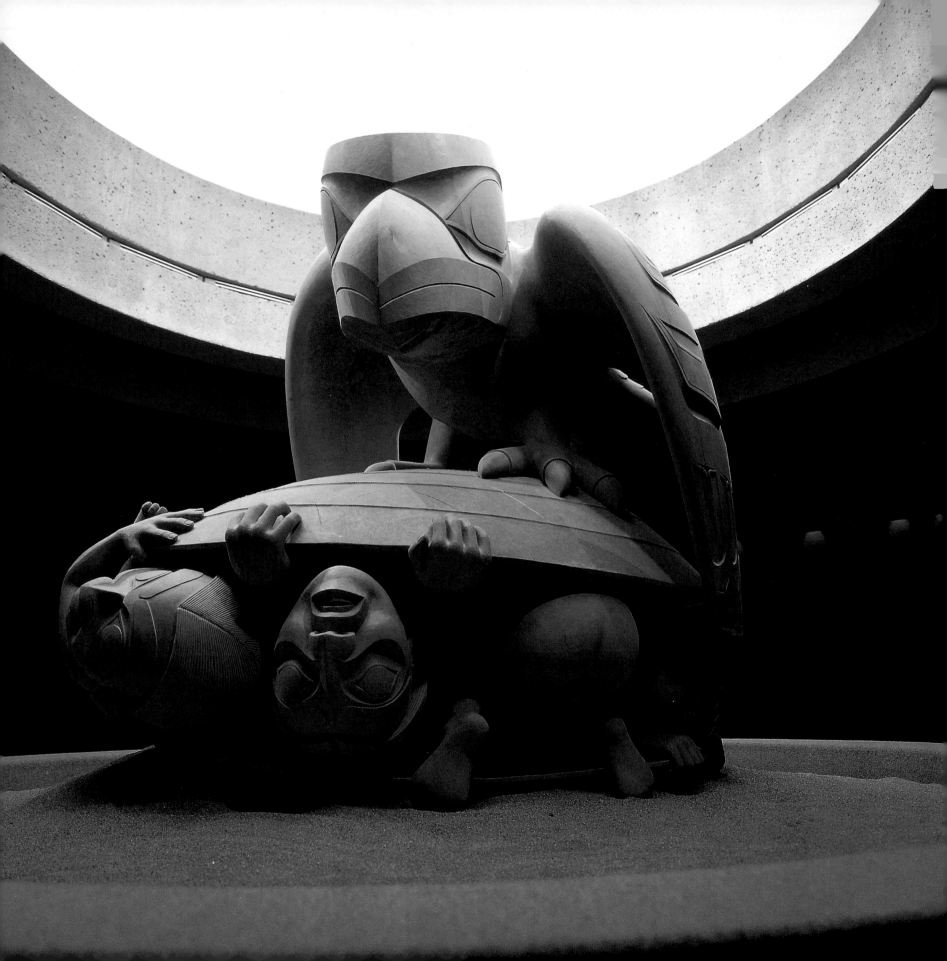

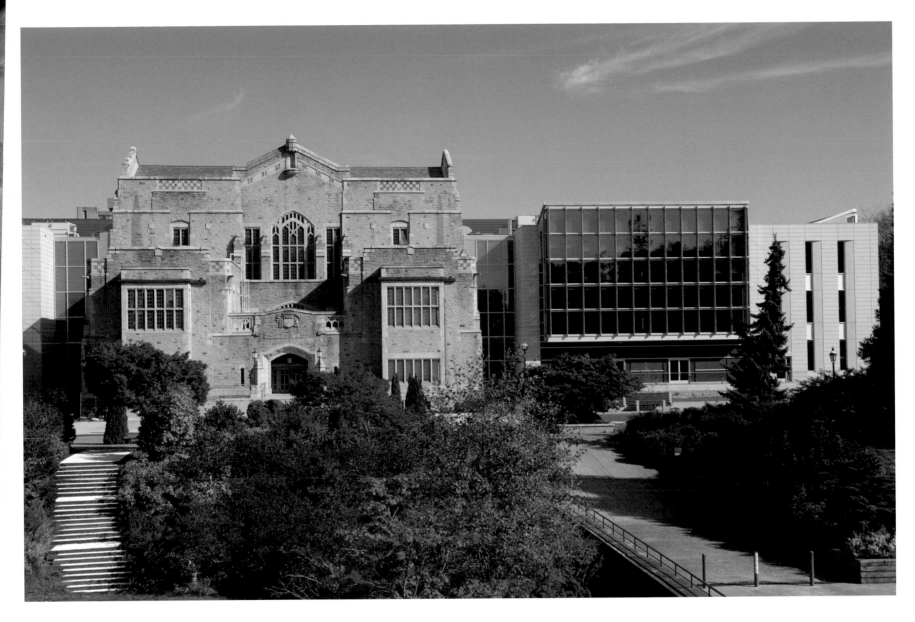

The University of British Columbia was founded in 1908. For years, classes were held in temporary shacks, but due to a massive student protest in 1922, the government granted $1.5 million to build facilities. Permanent buildings and faculties opened their doors three years later.

Bill Reid's stunning cedar sculpture illustrates the Haida story of human creation. *Raven and the First Men* is on display at the Museum of Anthropology, which houses one of the world's finest collections of Northwest Coast First Nations art and artifacts.

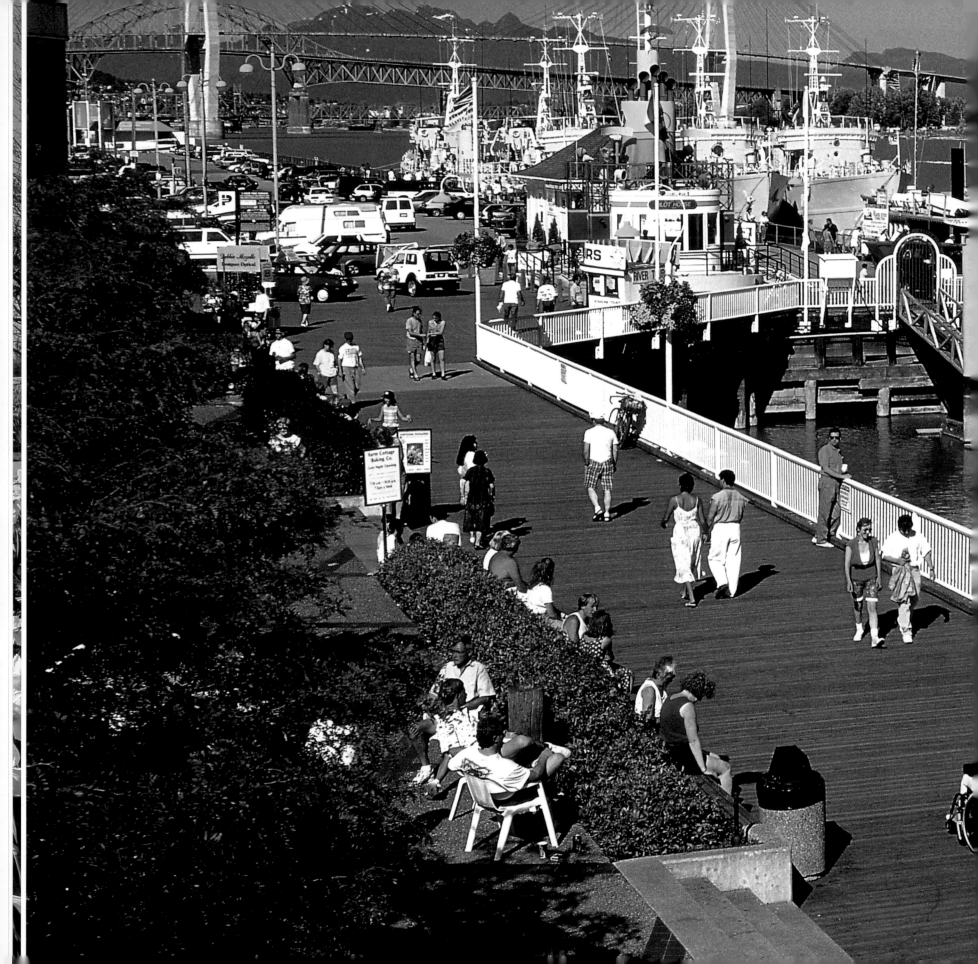

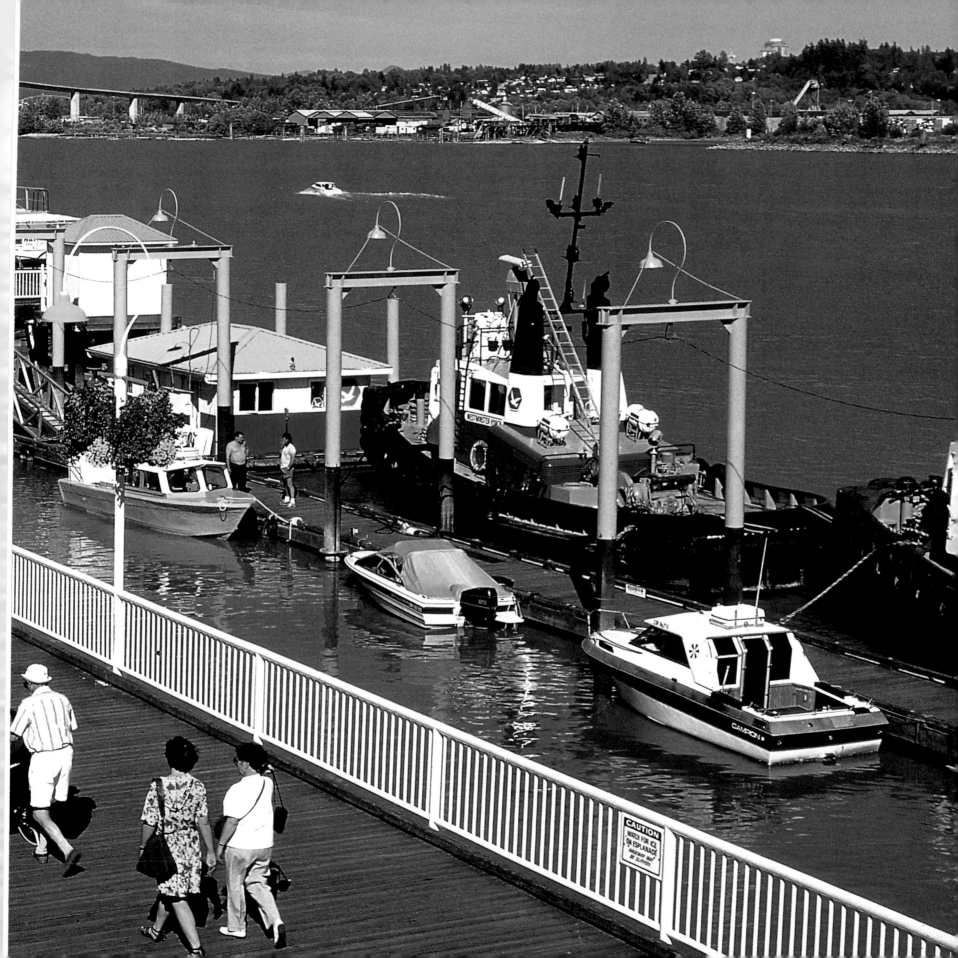

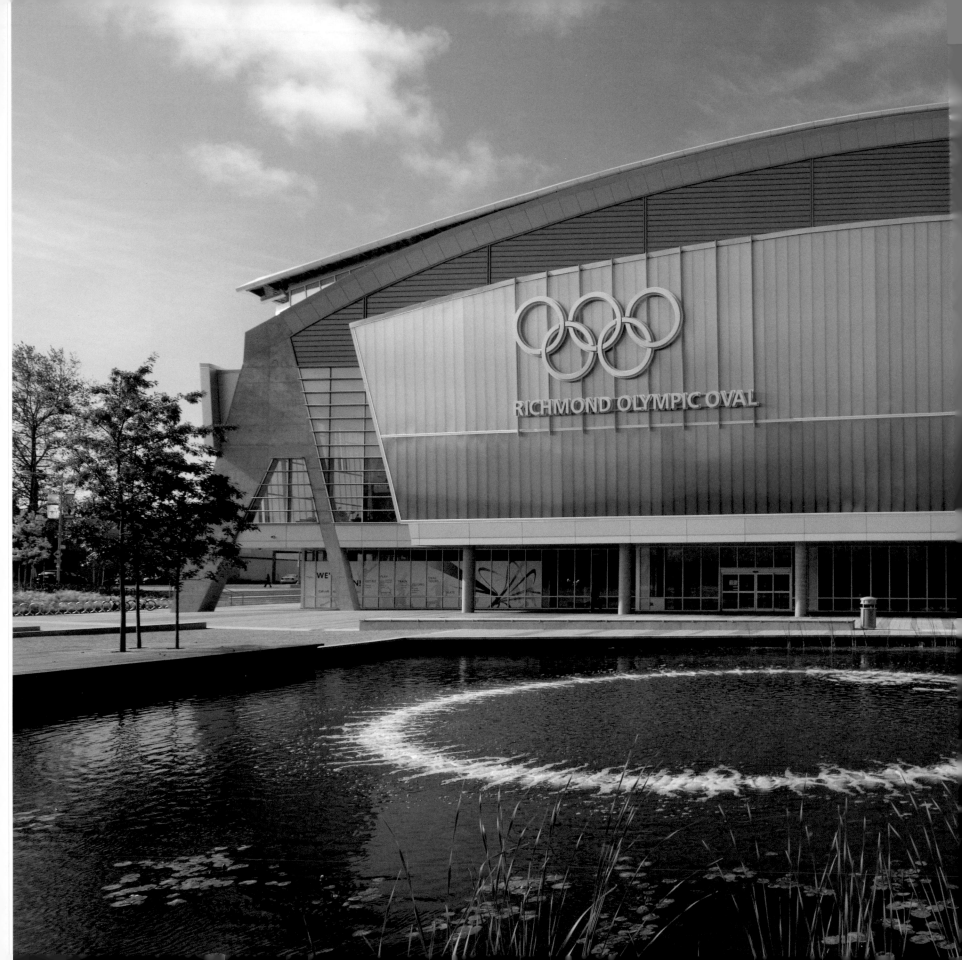

Constructed for the 2010 Winter Olympics, the Richmond speed-skating oval boasts 48,000 square metres of recreational space, and can seat 8,000 spectators.

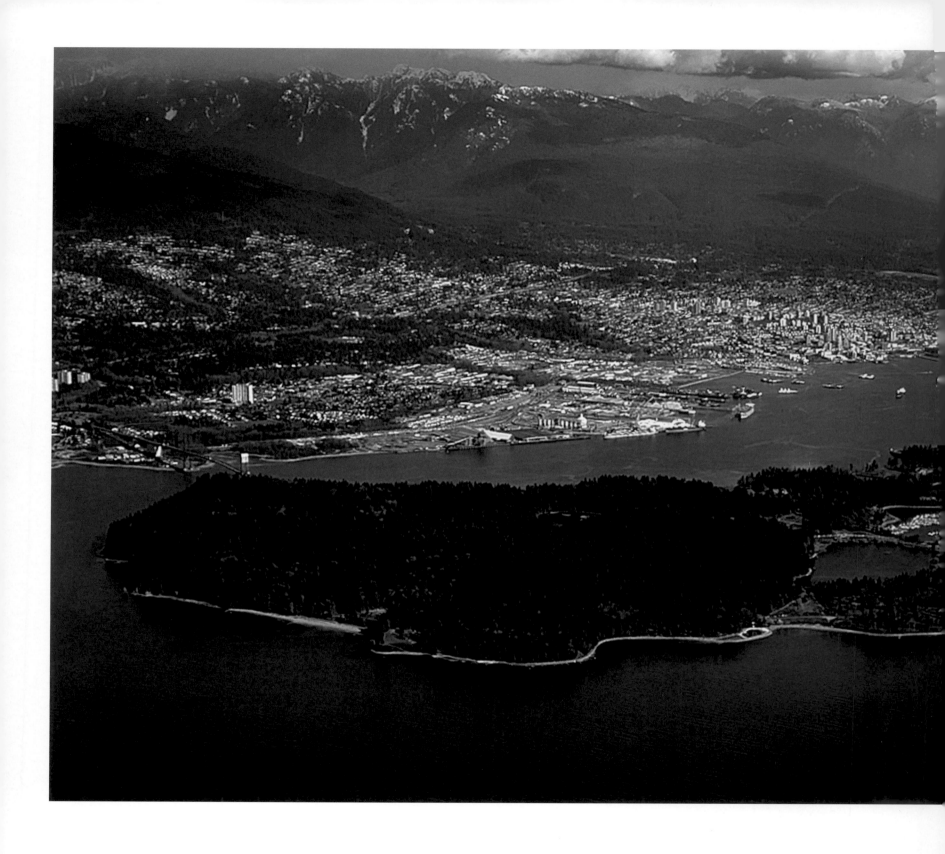

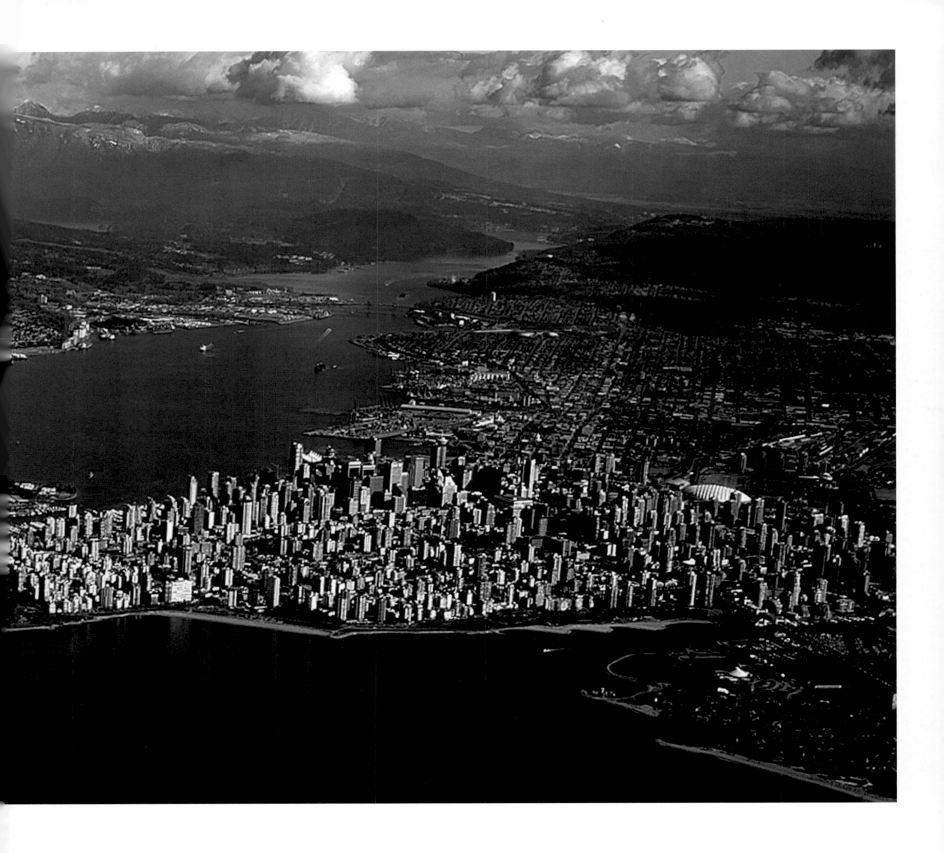

Stanley Park's renown as an emerald jewel in Vancouver's crown is evident in this image, which depicts the downtown peninsula, Burrard Inlet, and the North Shore.

Photo Credits

Jürgen Vogt 1/3, 12, 13, 16-17, 18, 23, 26, 28-29, 42-43, 48, 62-63, 64, 77, 91, 92-93

Jose Fuste Raga/First Light 6-7

Michael Wheatley/www.michaelwheatley.ca 20-21, 24-25

Chris Cheadle Photography 38-39, 40

Ron Watts/First Light 8, 14, 15, 19, 30, 34-35, 41, 44, 50, 55, 68, 72, 73, 86-87, 90

Ken Straiton/First Light 9, 10, 32-33, 36, 47, 54

Alan Sirulnikoff/First Light 11, 37, 58-59, 61, 74-75

Alan Marsh/First Light 22

Michael E. Burch 27, 46, 49, 51, 65, 66-67, 69, 70-71, 81

Steve Short/First Light 31, 78-79, 80

David Nunuk/First Light 45

Dolores Baswick/First Light 52-53

Donald Denton/First Light 56

Patrick Morrow/First Light 57

Thomas Kitchin/First Light 60, 84

Janet Dwyer/First Light 76

Adam Gibbs 85, 88, 89

Jason Puddifoot/First Light 82-83

Manfred Kraus/www.vancouvermoments.com 94-95